I MET THE WALRUS

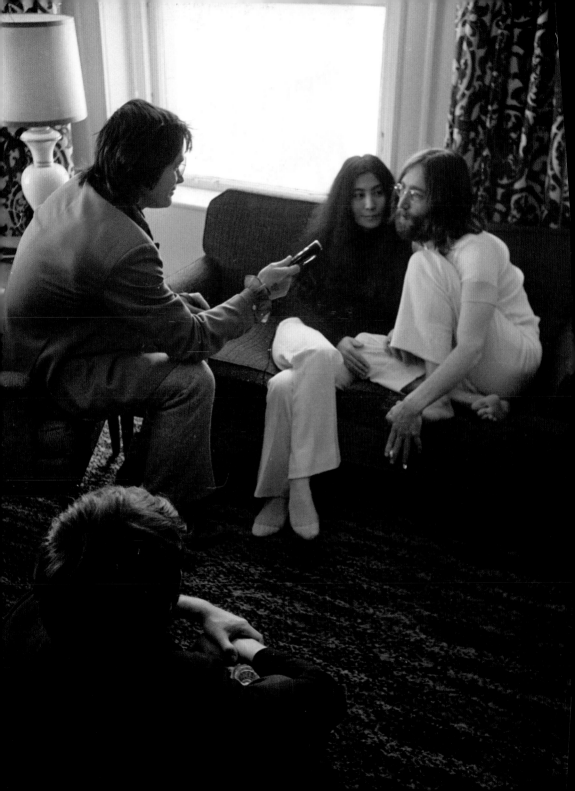

I MET THE WALRUS

HOW ONE DAY WITH JOHN LENNON CHANGED MY LIFE FOREVER

JERRY LEVITAN

COLLINS DESIGN
An Imprint of HarperCollins Publishers

CONTENTS

||||||||

TO MY BELOVED PARENTS,
CHONON AND JUDITH LEVITAN.
THEY HAD FAITH IN ME,
BELIEVED IN ME, AND LOVED ME.

||||||||

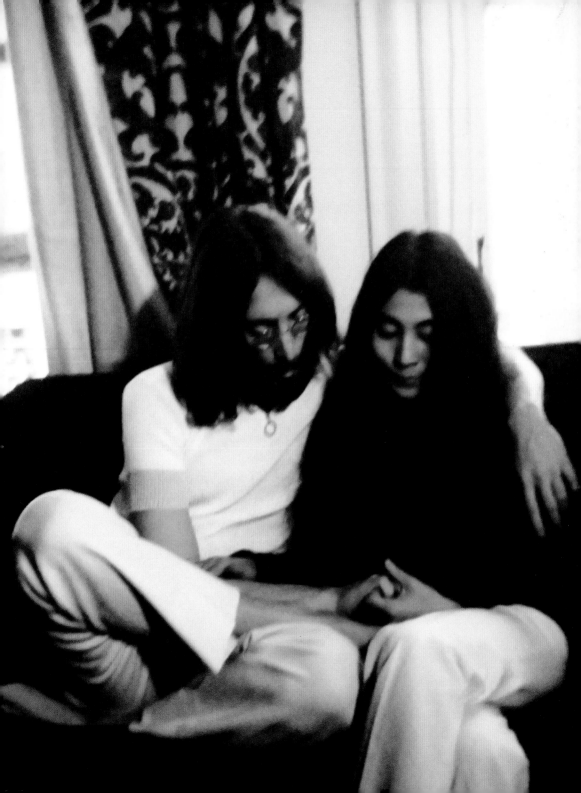

"I REMEMBER FONDLY, HOW YOUNG JERRY CAME TO US AND DID THE INTERVIEW, WHEN SO MANY JOURNALISTS WERE TRYING TO SPEAK TO US. HE WAS NOT ONLY BRAVE BUT VERY CLEAR AND INTELLIGENT. BOTH JOHN AND I THOUGHT IT WAS A VERY PLEASANT EXPERIENCE."

YOKO ONO

MEET THE BEATLES

I was nine years old when the Beatles first performed on the *Ed Sullivan Show* in 1964. It was February 9, and like millions of other families in those days, we sat around the TV each Sunday night at 8:00 P.M. to be entertained by that awkward yet strangely captivating impresario. That night there was a special buzz to his show. He was to showcase his latest find, four lads from Liverpool, England, who were taking their country and the music world by storm. The Beatles were something special. Girls screamed and fainted at the sight of them. Their mop-top haircuts made them controversial and gave them a slight edge of mystery and danger. Everyone anticipated their appearance for different reasons. I was practically vibrating from all the excitement.

Sullivan came on the black-and-white TV and in his distinct speaking manner said, "This city never has witnessed the excitement stirred by these youngsters from Liverpool who call themselves the Beatles. Ladies and Gentlemen . . . the Beatles!" With that announcement, my family and a nation were mesmerized as they opened the show with "All My Loving," accompanied by high-pitched, never-ending screams from teenage girls. John, Paul, George, and Ringo were confident and cute as they performed four other songs ("Till There Was You," "She Loves You," "I Saw Her Standing There," and "I Want to Hold Your Hand") between the other acts, including a

magician performing a card and saltshaker trick, an impressionist, and a comedy acrobatic troupe. The Beatles took my breath away. I had officially witnessed my first great spectacle.

Ringo kept the happy beat on an elevated stage looking down on his mates on a set that had huge arrows pointing at them. Paul played his distinctive, violin-shaped left-handed bass; George was on lead guitar. But John—standing in that quintessential Lennon style, defiant, guitar high up against his chest, legs apart—was clearly the band's leader. They bounced to the beat, well dressed in black suits, thin black ties, and pointed Beatle boots. And, relative to most other people at the time, longish wavy hair. This was a new kind of rock and roll star. The camera would cut away to shots of young girls in various fits of ecstasy and insanity, and a smattering of boys, who were in rapt, yet reserved attention. At one point their first names were flashed on the screen under their faces: "Paul," "George," "Ringo," "John: Sorry girls, he's married." The cultural phenomenon that was the Beatles was well underway that night as a history-making seventy-three million North Americans tuned in to see what the fuss was all about.

Something happened to me when I saw the Beatles for the first time. Before then my heroes had been comic book characters like Superman and Batman. But the Beatles were something better. They were superheroes with instruments and great musical powers. They were instantly familiar to me and I trusted them immediately. I had found new heroes to worship.

It couldn't have been a better time for the country to meet the Beatles. Just three months before their introduction to North America, the world was jolted by the assassination of President

John F. Kennedy. Kennedy represented hope and a new beginning for the baby boom generation.

When JFK died so violently it shocked the world. Canada was no exception. I remember sitting in my classroom in school when an emergency announcement came on from the principal that President Kennedy had been shot and school was cancelled. I left class that day and watched teachers and random people on the street weeping for themselves and the fate of the world. I came home to my devastated mother and aunt. It was as though the world had come to an end. For the burgeoning television generation that I was part of, the coverage of Kennedy's assassination and its aftermath was overwhelming. That heavy cloud was the backdrop to Ed Sullivan's gift to North America that February night. It has been said so many times before, but the Beatles really were what the Western world was waiting for. Everyone, particularly my generation, needed a reason to believe that the world was a good place, that our lives had meaning, and that our future held promise.

Exposure to pop culture was limited in the early '60s. There was no MTV or VH1—only television variety shows, movies, radio, and print. That meant that if you wanted to know what was happening in the music scene you had to listen to your favorite pop radio station, catch the hottest TV show, and speak to your friends to keep up. My brother, Steve, and sister, Myrna, were older and more in tune with what was happening and I went along for the ride. They had the turntable and the records. I had the comics.

Before the Beatles, the pop charts were filled with bouncy pop tunes like crooner Steve Lawrence's "Go Away Little Girl," the Four

Seasons'"Walk Like a Man," "He's So Fine" by the Chiffons, and "Blue Velvet" by Bobby Vinton. These were sweet, nonthreatening songs that the whole family could love. One-hit wonders sung by finely groomed white teenagers filled the airwaves. It was a far cry from the hip-shaking, lip-snarling "Jailhouse Rock" of Elvis Presley just a few years before.

Elvis had been drafted into the army in 1958, sent to Germany, and rock and roll had taken a turn for the worse. During his absence the charts were littered with fluff like "Venus," "Alley-Oop," "The Chipmunk Song," and "Itsy Bitsy Teenie Weenie Yellow Polkadot Bikini." When Elvis and his particularly "deviant" music left the scene, the moguls of the recording industry—with some prodding from parent groups and congressmen— encouraged a cleaner, whiter diet of all-American pop.

Some musical gems managed to sneak through, however, and many of these reached the Beatles when the Atlantic ships docked in the port of Liverpool bringing goods from America, including records like "Kansas City," "Will You Love Me Tomorrow," "Mack the Knife," "Hit the Road Jack," and "Please Mr. Postman." It was these songs plus those by Buddy Holly, Chuck Berry, Little Richard, and of course, pre-Army Elvis that had the greatest influence on the Beatles.

The day Elvis was inducted into the Army, March 24, 1958, John Lennon was seventeen years old and Paul McCartney just fifteen. The world's greatest songwriting team had met less than a year earlier, on July 6, 1957. That day, Paul McCartney impressed John with his ability to sing all the lyrics to Eddie Cochrane's "Twenty Flight Rock." Within a day, he was invited to join Lennon's group, then called the Quarrymen after John's high school, Quarry Bank. Within weeks, Paul's younger mate George Harrison came on board. A few years later, the ill-fated Pete Best was dumped to make room for Ringo Starr, and the Fab Four as we know it was created. Within five years they would be on the cusp of history-making stardom with the release of "Love Me Do" in the UK on October 5, 1962.

Right around the Sullivan broadcast I remember working on a school project on the Guttenberg Bible one Sunday with a classmate at his place. We were teamed up and I was fixated on cutting and pasting text and photos onto the bristle board. He was busy spinning records, one in particular, *Meet the Beatles*. He played it over and over again. At first he was annoying me because I was doing all the work. But the distraction slowly became fascinating. "Listen to this one," he would say. "Paul sings lead." "That's John on the harmonica." Increasingly my attention was drawn away from what I was doing and I was standing side by side with him at the hi-fi in his parents' recreation room watching the record spin and examining the album.

Most of the songs were familiar to me. You had to have been on the moon not to have heard "I Want to Hold Your Hand," "I Saw Her Standing There," or "All My Loving." The less-played songs were visions into the group's future. George's "Don't Bother Me" with the bongo beat. The minor chord in "Not a Second Time." The affectations had already become pop legend: "Yeah, yeah, yeah." The harmonica. Inventive harmonies. Ringo shaking his head and all those crazy rings. Examining that album and listening to the songs over and over while we neglected our project was like going through a portal to a new dimension.

Meet the Beatles was released on January 20, 1964. The release of the singles "Please Please Me," "From Me to You," "She Loves You," and "I Want to Hold Your Hand" was already causing sensations everywhere with their distinctive, joyous sound. The harmonies and hooks were different and enticing. The Dave Clark Five, Freddie and the Dreamers, Gerry and the Pacemakers, Herman's Hermits, the Animals, and the Rolling Stones would all travel the intercontinental road to America paved by the Beatles. North America's appetite for a new style of pop and rock had become insatiable.

By 1964 the charts were being filled with a different range of music than the safe and clean tunes of just a year before. "I Get Around" by the Beach Boys, "Pretty Woman" by Roy Orbison, and albums by Bob Dylan, Dusty Springfield, the Yardbirds, and the Rolling Stones broadened the range of music for young people and the possibilities for change. These songs left the increasingly banal and novel songs of the early '60s in the dust and the Beatles were leading the way, even writing chart toppers for other bands (the Stones' first

big hit, "I Wanna Be Your Man," was a Lennon/McCartney original).

It didn't take long for the Beatles to infiltrate the pop lexicon. There were numerous references to them in situation comedies and films and parodies on variety shows. Comics would wear wigs and mimic the Liverpudlian accent. They would sing badly and goof around. Peter Sellers recorded "She Loves You" (inspired by Dr. Strangelove) reciting the lyrics in a German accent. That is how the establishment saw them—fun loving, harmless, and cute. But kids at the time knew differently. They understood that the Beatles were leading the vanguard of a new era of music and pop culture.

I was not a stranger to music and performers. My father played the mandolin with passion and style. He had a discerning taste for talent. In fact, the night the Beatles were on *Ed Sullivan* he taught himself to play "All My Loving" perfectly. He would often say that had he been dropped off in Hollywood as a young man he would have fit right in. That my father so overtly liked the Beatles that first night reinforced my instincts.

My parents were the first generation of my family in North America. They had left Europe a few years after the ravages of World War II and found themselves with their young daughter in Canada. They were en route with other refugees to New York City, but the quota system detoured them to Halifax, Montreal, and then Toronto. Steve and I were born in the New World. When I was ten, we moved to a middle-class suburb called North York. It was an area mostly populated with concentration camp survivors. Looking back, I would place my friends' parents in two categories: the Bitterly Affected and the Hopeful Rebuilders. My parents were in the latter category. They had their dark moments, particularly my father, but they worked hard to build a

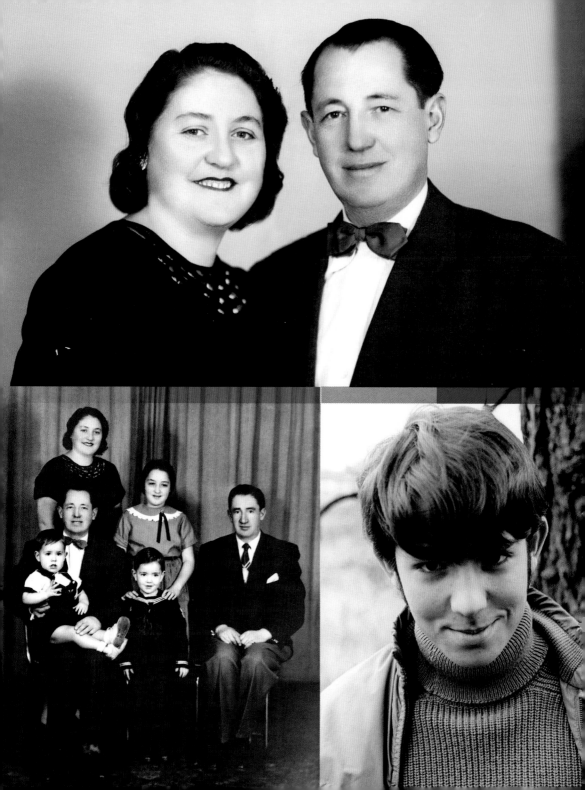

family and give their children a promising future. My mother loved to sing and write; my father loved to dance, play the mandolin, and tell stories. My Uncle Mike told jokes, squeezed the accordion, and belted out either a song he wrote or a popular tune. Our home was a variety show, and whatever gave us kids joy, my parents supported.

As I approached my early teens, I had fully embraced everything the Beatles represented. From music to clothes to hairstyle to outlook on the world, they were the standard bearers. Before then I was familiar with their songs and had seen the films *Help!* and *A Hard Day's Night*. Adults talked about them all the time, mostly with alarm, so I knew they were important. For most people, the phenomenon that was the Beatles became very much an individual identification with each member of the group and wanting to please them. When George said jelly babies were his favorite candy, the Beatles were showered with them on stage and in the mail. Starting in 1963, the Beatles made it a practice to send a six- or seven-minute Beatle Christmas record to fans of the official Beatles fan club. The recordings were improvisational and comedic and once included an appearance by Tiny Tim.

Paul had this to say in a 1963 Christmas record the Beatles sent to their fans:

> Oh yeah, somebody asked us if we still like jelly babies? Well, we used to like them, in fact we loved them and said so in one of the papers, you see. Ever since we've been getting them in boxes, packets, and crates. Anyway, we've gone right off jelly babies, you see, but we still like peppermint creams, chocolate drops, and dolly mixtures and all that sort of things. (Yes! Yes! Oh yes!)

Girls would go to concerts and wave signs that read "I Love You Paul." It took a bold boy in those days to let a specific alignment to his favorite Beatle be known. But as time went on, even boys would "choose" the Beatle they liked best and have arguments and discussions about why. Paul was the cute, lovable one, always aiming to please. George was reserved and mysterious. Ringo, fun loving and forlorn. John, witty, wry, and otherworldly. The four personalities that were the Beatles were under such scrutiny individually and as a band that the screaming fans and the relentless marketing of Beatlemania unwittingly contributed to the group's disintegration by the end of the decade. No other rock group, not even the Rolling Stones, ever experienced anything like that.

Though I loved them all, and was particularly reverent of the songwriting partnership of Lennon and McCartney, I idolized everything about John: his courage and cockiness, his humor and whimsy. Intelligent, always on a quest, and fiercely original, John was who I wanted to be. He had an imagination that

captivated me. There was honesty and real pain in his songs, no matter how upbeat the sound was. I think I related to that. John confronted the hardship of life and morphed it into messages of hope and joy.

Early on I developed a passionate identification with John, though I could never have predicted where that passion would eventually take me. One of my friends was adamant that George was the best in the group. We would argue vehemently about that to the point where I would not speak to him for weeks. The truth is that I would have proclaimed my admiration and loyalty for each of them to the outside world. I loved George and Ringo and idolized Paul. But I had to let it be known, in a missionary way, that John was unquestionably the leader, that he was the best, and that the other Beatles knew it too.

As I got older I was witness to the evolution of the Beatles and their constant preeminence in pop. My siblings would buy the new albums, and I would sneak into their rooms and listen to them when they weren't there. They did a lot of covers in their first few records—tributes to their favorite artists—like "Baby It's You," "Chains," "Twist and Shout," "Long Tall Sally," "Money," and "Roll Over Beethoven." In the summer of 1964, when I was ten, my sister took my brother and me to see *A Hard Day's Night*. That film was a sensation in glorious black and white. The Beatles at their mischievous, musical, and marvelous best.

A Hard Day's Night, the album, had bouncy interesting tracks starting with the jarring guitar chord that opened the title song. "Can't Buy Me Love" always brought me back to my favorite scene in the movie where the Beatles ran around a field in fast motion playing silly soccer like the happy brothers they were. John gave "I Should Have

Known Better" its hook with his harmonica playing. Both John and Paul wrote beautiful ballads—the acoustic-guitar-driven "And I Love Her" and John's "If I Fell." This was a special album because of its connection to the movie and because of the increasing complexity of the songs. And for the first time, there were no cover songs. All songs, except one by George, were written by Lennon and McCartney. That was virtually unprecedented in pop music.

By the end of the year, the Beatles had produced another album, *Beatles '65*. As I got older, these new songs increasingly appealed to my adolescent emotions. John had two songs of hurt, "No Reply" and "I'm A Loser." Within six months the group had released, *Beatles VI*, with the songs "Eight Days a Week" and "What You're Doing." And within two months, *Help!*

Help! the record, came out on August 13, 1965, twelve days before the film. It slashed its way into the charts. Just the idea of the title track was odd enough for the biggest pop group of them all. John would later say that it was his unhappiness with the Beatles' fame and its effect on his personal life that was behind the lyrics. The ads for the film were everywhere.

STOP WORRYING!
HELP!
IS ON THE WAY!
THE COLORFUL ADVENTURES OF THE BEATLES
ARE MORE COLORFUL THAN EVER. . . . IN COLOR!

Colorful, cartoony, zany. It was exactly what I wanted to see. James Bond spoofs, pratfalls, jokes galore, I was on the edge of my seat the whole time. The songs were as vivid and melodic as ever with "Ticket to Ride," "You've Got to Hide Your Love Away," and "You're Going to Lose That Girl." How could an eleven-year-old boy not love that the Beatles slept together in the same apartment? John in his pit reading his own book, Ringo with his food dispenser, Paul playing the lighted organ, and George keeping to himself. Mad scientists, strange people from exotic lands, skiing, the Bahamas, bombs, lasers, the Queen. It was so much fun.

Remarkably, within four months, *Rubber Soul* was released in December 1965. The Beatles were serious now. "Norwegian Wood (This Bird Has Flown)," "Michelle," "Think for Yourself," "The Word," "I'm Looking Through You," and the spectacular "In My Life." I spent a lot of time, without success, trying to figure out what the phrase "rubber soul" meant.

I was twelve when *Yesterday . . . And Today* came out in June 1966. "Drive My Car," "Yesterday," "Nowhere Man," "We Can Work It Out," "Day Tripper." John blew me away, yet again, with the lazy, crazy "I'm Only Sleeping" that combined backward loops and poetic lines. Each of these songs hinted at adventures to come, for them and for my remaining teenage years. I increasingly related to the personal stories the Beatles told in song, especially when John sang lyrics like: "When I'm in the middle of a dream, stay in bed, float upstream." Because the songs were so honest and revealing, I connected to them deeply. They started to feel like trusted friends who understood and accepted me. When I listened to Beatles songs, I finally felt like I fit in somewhere.

But even though I loved the albums it was clear that something was changing. The Beatles were growing and so was I.

When *Revolver* appeared in 1966, my imagination hit its trajectory. First, the album cover was an illustrated whirlwind of joyous personality. Their hair like twirling spaghetti surrounded photos and images of what the Beatles were becoming. You did not just listen to records in those days. You consumed them, poring over the album covers, inserts, and liner notes. Like all things, the Beatles set the standard in covers and *Revolver*'s—designed by Klaus Voorman, a German friend from their days in Hamburg—was an iconic standout, still instantly recognizable forty years later. An album cover as bold and adventurous as the songs—"Taxman," "Eleanor Rigby," "She Said She Said," "For No One," "Tomorrow Never Knows." So melodic. So much fun. So mysterious. They told me about the Beatles' lives. What they were experiencing. How grand life could be. They were showing me a world that was magnificent, wondrous, and exciting, even more so with them in it.

The number one hits of 1966 around the time of *Revolver*'s release were "Hanky Panky" by Tommy James & the Shondells, "Strangers In the Night" by Frank Sinatra, "Cherish" by the Association, and "Paint It Black" by the Rolling Stones. Though great songs and catchy tunes, the Beatles' *Revolver* eclipsed them all with experimentation and artistic depth. Each of the Beatles made the listener witness to the changes and growth he was experiencing. These were not the love songs of the Beatles' other albums. They were complicated musically and lyrically. The sitar that was just an affectation in "Norwegian

Wood" was now part of a full Indian ensemble in George's "Love You To." The lead guitar (Paul's contribution) on "Taxman" was jarring and fantastic. Beautiful and haunting, "Eleanor Rigby" spoke of loneliness and empathy. "Tomorrow Never Knows" took us through a time warp converging the past and the future. I listened to *Revolver* incessantly. My musical tastes, my values, and my conscious life were in no small part being structured by the Beatles and this album in particular. It was at this moment that I believe I appropriated the Beatles completely for they could do no wrong. They felt the passion I felt for life. We were in it together.

Even during controversy, I was behind my heroes all the way. During their final 1966 tour, word spread rapidly about an interview John Lennon gave to the *Evening Standard* in England that was published on March 4, 1966. In that interview, and in the context of commenting on the fame of the Beatles, he said:

> Christianity will go. It will vanish and shrink. I needn't argue with that; I'm right and I will be proved right. We're more popular than Jesus now; I don't know which will go first—rock and roll or Christianity. Jesus was all right, but his disciples were thick and ordinary. It's them twisting it that ruins it for me.

That comment exploded in the States. Record burnings, protests, the Ku Klux Klan, death threats—all those things happened during that tour. It frightened the Beatles and their handlers. The outcry was so

great that John was pressured to hold a press conference on August 11, 1966, to explain himself. Looking pained, but with his Beatle brothers at his side, he was reservedly contrite.

> *I suppose if I had said television was more popular than Jesus, I would have gotten away with it. I'm sorry I opened my mouth. I'm not anti-God, anti-Christ, or anti-religion. I wasn't knocking it or putting it down. I was just saying it as a fact and it's true more for England than here. I'm not saying that we're better or greater, or comparing us with Jesus Christ as a person or God as a thing or whatever it is. I just said what I said and it was wrong. Or it was taken wrong. And now it's all this.*

I remember how frightening that was. Some members of the media were beginning to turn on the Fab Four. Those who always saw them as a threat were using this as proof of their insidious influence. First long hair. Then lasciviousness. And now blasphemy. John's experience during that time in no small part laid the seeds of the peace campaign that would be the catalyst for a revolution for many people and in my life particularly.

Nineteen sixty-six was a time of many formative pop influences on me in addition to the Beatles, and yet they all seemed to go together. The *Batman* TV show with its campy, pastel-color aesthetic. Peter Sellers. James Bond. Burt Bacharach. *Star Trek*. All contributed to the fabric of my emerging consciousness with the Beatles conducting the show.

The first record I ever owned was *Sgt. Pepper's Lonely Hearts Club Band.* It was a bar mitzvah gift. I was already fully aware of the album. Both my sister and brother had copies, and it permeated the times. But having my own copy was a thrill. Nothing had sounded anything like it before. The level of production was rich and innovative. Each song was a complex story told with flair and style. The Beatles had spent some six months recording the album, which was unprecedented for the time. But again, it was the album cover that perhaps made the biggest statement.

This was the Beatles deconstructing themselves. Dressed in spectacularly colorful satin uniforms, they were depicted attending their own funeral. With knowing smirks on their faces, the Beatles surrounded themselves with life-size cutouts of seventy of the most famous and infamous people in the world—including the Fab Four themselves in wax, on loan from Madame Tussauds. This rebirth was overseen by iconic images of W. C. Fields, Bob Dylan, Marilyn Monroe, Sigmund Freud, Karl Marx, and Edgar Allen Poe. They knew it was zeitgeist time and they had broken the barrier. Everyone talked about that album. When *Sgt. Pepper* came out, the Beatles owned the world.

Following the Beatles' story became the driving force of my young life. I was their fiercest defender and proponent and made it clear to everyone and anyone that they were my number one heroes. And they never, ever let me down. After *Sgt. Pepper* came *Magical Mystery Tour.* How fantastical was that? The album from their self-produced TV film proclaimed that the Beatles of old were gone, that *Sgt. Pepper* was not a fluke, and that they were truly gods walking the earth. At least that's how I saw it. On that 3-D album cover were the Beatles in animal

WALRUS

costumes amidst stars and psychedelic colors. On the inside was the song that became the soundtrack of my life: "I Am the Walrus." John's powerful epic poem that hovered around a constant wailing siren made my heart beat fast and furious. Every word and thought, every enunciation overwhelmed me. Still does.

The albums never grew old. I listened to them so often that I must have owned three or four copies of each title over the years because of the wear and tear. The Beatles released at least two albums a year, and if that was not enough, they always treated their fans with singles in between: "All You Need is Love," "Penny Lane" and "Strawberry Fields," "Lady Madonna." These singles had lives of their own.

The Beatles stopped touring after their Candlestick Park concert in San Francisco on August 29, 1966. As George would later say, "The audience gave their money . . . we gave our central nervous systems." Instead, they focused on the recording studio. To keep in touch, they pioneered the music video, sending film to accompany their singles to *Ed Sullivan* and other top variety shows. That in itself was an event that would be advertised: "See and hear the Beatles' latest single on the next *Ed Sullivan Show*." "Paperback Writer" and "Rain" had the Beatles cavorting about in a garden. Increasingly they became more comfortable and carefree on screen. Paul showed off a chipped tooth from a car accident. John wore groovy sunglasses. Hip, sporty, and casual. "Penny Lane" had the Beatles mustached, dandied up, walking through childhood routes in Liverpool. A candelabrum was placed on their table by Victorian servants as they dined in the park with their instruments.

For "Strawberry Fields," we witnessed the arrival of John's trademark granny glasses, his eyes ever-peering, glazed, and all-knowing. Psychedelic pop was born. "Hello Goodbye" had the Beatles in party overdrive, dancing with hula girls and sporting their *Sgt. Pepper* outfits. The anticipation of watching these gifts from the Beatles on TV was electric.

When "Hey Jude" premiered on the *Smothers Brothers Comedy Hour* on October 6, 1968, it displaced Jeannie C. Riley's "Harper Valley PTA" from its number one spot. The opening frame was Paul at the piano, John on bass, George on guitar, and Ringo on drums. All close together, supporting Paul, with those big brown eyes, singing away. When the great chorus kicked in, the Beatles let a crowd of people off the streets in to swarm them, touch them, and belt out the chorus. Wow! The video for "Revolution" was aired one week after "Hey Jude," again on the *Smothers Brothers*. Every song they released wasn't just a hit; it was an event constantly topping the one before it.

For the first time, the Beatles' own record label logo, Apple, appeared. On one side, granny smith green. On the other, white and sliced with the seeds on display. "Revolution" was the sliced apple and was as edgy and rocking as anything

the Beatles had done before. "If you go carrying pictures of Chairman Mao, you ain't gonna make it with anyone anyhow." Only John Lennon could get away with lyrics like that.

Since they were no longer touring, they weren't forced to be prisoners to nerve-wracking world tours. And so the Beatles began searching for meaning in their art and in their lives. As their personal horizons expanded—drugs, meditation, exposure to other musicians—so did their music, the presentation of it and their aesthetic. George Harrison's wife Patti told them of this wonderful mystic from the East, the Maharishi Mahesh Yogi. They attended a lecture he was giving in Wales, and it was on the second day of that retreat, August 27, 1967, that they learned that their manager Brian Epstein had died due to drugs and mysterious circumstances. Epstein was twenty-seven when he found the Beatles at a club called the Cavern. He championed them from the beginning, when he still worked in his father's appliance store in Liverpool, all the way to the behemoth they had become. It shocked them, and as John would later say, he thought the Beatles were finished after that.

Scared and directionless, they continued their infatuation with their guru, a word that became known to millions of kids, including me. It seemed to cut across religious differences and the Beatles were now exploring spirituality and involving all of their fans in that

quest. The Beatles went to Rishikesh, India, in February 1968, not to tour but to study for weeks with the Maharishi. It was so exotic, so fascinating, and I could not wait to hear what they would say when they emerged. It was during that pilgrimage that they produced some of their finest, most personal and biting songs, songs that would form the content of the *White Album*. When word spread that a new release from the Beatles was coming, it was shrouded in secrecy, and arrived on the pop scene like a bomb. Getting an album was not the easiest thing for a suburban kid in those days. They were not available everywhere. The place of choice in Toronto was Sam the Record Man. Three creaky wooden floors of vinyl. When you walked in, it felt like you were entering a temple of music and pop culture. I would spend hours there, even if I did not buy anything. The first floor was rock and pop. The second floor was show tunes, adult contemporary, and jazz. The top floor was classical. The ceilings were low and the rooms were connected by narrow aisles and square pillars. The rim of the ceiling and walls were lined, throughout the store, with 8 x 10 framed photos of recording artists from Judy Collins to Jimmy Durante, all with Sam "the Record Man"

Sniderman hugging them or mugging with them. I knew every one of those hundreds of photos. That's what it was like, for me, going to Sam's in November 1968 to get the *White Album*.

I would call Capitol Records as soon as I heard of a new Beatles recording to get the release date and then the delivery date. Without fail, from *Sgt. Pepper* on, I was in the alley behind Sam's waiting for the Capitol truck. I did the same that November, shivering behind the store until it pulled up. The driver unloaded boxes with the Capitol Records logo and I watched as the first box was opened on the floor in the back of the store. Everything was white inside. It was as though someone had dumped paint into the box and it had hardened. I was given one of them and clutched it in my hands. It was pure as pure could be. It was the antithesis of the colorful and exuberant album covers that preceded it. Faintly, I could see the Beatles name embossed on the bottom right of each album. I remember that wondrous moment clearly.

A few songs were getting airplay about a week before the album's release. In the car one night, I heard "Back in the USSR" on the radio for the first time. It started with the sound of a jet plane. And then it landed, full force with a thumping beat. That specific emotion is forged into my memory. So when I ultimately bought the *White Album* and held it in my arms, I knew something of what I was about to experience. But I had heard only a few songs on the radio and this was a double album with thirty new Beatle songs! I stared at the cellophane-wrapped *White Album* for the ride home. I did not want to open it yet. It had to be done right.

We did not have headphones, so I put my small, portable hi-fi on my night table. I lay on my bed, facing up, with the speakers on

either side of my head to get the full effect. When the needle hit the outside of the record, even a new record, you heard the comforting mellow sound of friction. I heard the slowly approaching airplane. By the time my uninterrupted adventure ended with Ringo singing "Goodnight," I was in transcendent splendor. Listening to it over and over again, all night, made me feel important, part of a special club selected by the Beatles to change the world. I studied those albums, word for word and sound by sound. Not a nuance passed me by. Having listened to Beatle records so often, I could discern who played what instrument, who made what sound, and who harmonized with whom. To this day, I hear a Beatle song as if it was in many different layers, songs within songs: Paul's melodic and imaginative bass lines, John's sharp guitar chords and Donovan-style finger picking, George's unique lead guitar, and Ringo always keeping it together with his simple yet brilliant hits on the drums. Every breath, sigh, grunt, and whistle was imprinted in my memory cells. The *White Album* was a gift. That was how I saw it.

With the *White Album*, or as I liked to call it, the double *White Album* because they'd given us an impressive two albums in one, the Beatles had gone beyond the bold experimentation of *Sgt. Pepper* and *Magical Mystery Tour*. They were now supreme craftsmen of expression, innovation, and presentation. And with the album came tangible goodies. Four 8 x 10 close-up portraits of each Beatle. No mugging for the camera anymore. No psychedelic art. Paul, with stubble, up close and personal. George, direct and purposeful. Ringo, stylishly eccentric. John, transmuted and disconnected. The Beatles seemed to have had a direct hand in preparing a poster of Polaroids,

proofs, and photos. These were not posed publicity shots but personal giveaways to the fans. The Beatles as they had become. In the bath. Contemplative. Naked. Stoned. And for the first time, Yoko Ono made her formal and dramatic appearance.

Stories of John's relationship with Yoko had started to surface. They met on November 9, 1966, at the Indica Gallery in London where Yoko's exhibition of *Unfinished Paintings and Objects* was on a private preview display. John climbed the ladder, gazed through a magnifying glass hanging from the ceiling, and read the word "YES." Later he would refer to that as being the moment of instant connection. Yoko Ono had already created a buzz in the art worlds of London and New York by staging such performance art events as sitting on a stage inviting the audience to cut her clothes until she was naked, covering the lion statues in Trafalgar Square with white sheets, and filming 365 naked behinds, one for every day of the year. John, the Philosopher King of Rock, had met his match.

Much of the newspaper and magazine coverage of Yoko was merciless and racist. She was ravaged and ridiculed—as was John—for the relationship, though scorn was added to him for having gone mad and breaking the Beatle mold. Rumors of discord amongst the band members started percolating and the usual focus was on Yoko. Fans did not know what to make of it. Her photo was in the poster. And her voice appeared three times. She sang backup vocals on "Birthday" with Maureen Starr. It was Yoko who answered John in the "Continuing Story of Bungalow Bill." "The children asked him if to kill was not a sin?" John sang. "Not when he looked so fierce," his "Mommy butted in." In "Revolution 9" she softly pronounced, "We stand naked."

I, however, adored it. First of all, John was in love. What was wrong with that? Second, they seemed to be of the same mindset. Positive. Experimental. Political. Funny. Finally, it was clearly what John needed to free himself from the monster that the Beatles had become. I was loyal to the bone. No matter what you thought of Yoko, the songs were so good, so new, so innovative that it was impossible to deny their genius.

There were songs of power, pain, and politics. Paul's "Blackbird" is his message of support to black women in America. George's "While My Guitar Gently Weeps" laments the alienation and detachment many people felt at the time. John throws a dagger at pop culture with the fragmented "Happiness Is a Warm Gun." A dramatic departure from their previous albums, there were only two romantic love

lectured about it on my soapbox. Having read everything I could about the making of it, I dazzled and bored kids and teachers with my knowledge. "Martha My Dear" was about Paul's sheepdog. "Dear Prudence" had its genesis in India with John and Paul trying to coax Mia Farrow's sister out of her cabin in the Maharishi's ashram. And "Sexy Sadie" was about John's eventual disillusionment with the Maharishi. "I'm So Tired" had John singing about trying to quit smoking and "Back In the USSR" gave loving tribute to the Beach Boys, Chuck Berry and Jerry Lee Lewis. The pinnacle for me, though not for everyone else, was "Revolution 9." It did not take me long to be able to mimic John's eight-minute-and-thirteen-second apocalyptic vision of the future. I can do it to this day. There was not

a note, a sound, an image, tone, or word that I did not worship about the double *White Album*.

The world had barely a week to digest this massive pop release when John and Yoko released through Apple *Unfinished Music No. 1: Two Virgins*. The front and back covers featured John and Yoko naked. The photos were taken by themselves and not manipulated in any way. No pop artist since has come anywhere close to such a dramatic, uncompromising act of defiant courage and audacity. John Lennon, emboldened by his new partner in love and art, took his stardom and twirled it in the air. As John said in his liner notes, he and Yoko "battled on against overwhelming oddities." John's friend and collaborator Paul McCartney lent a gracious quote that appeared on the front cover: "When two great Saints meet, it is a humbling experience. The long battles to prove he was a Saint." Paul was supportive of John but even then confused by his partner's latest venture. George Martin, the Beatles' legendary producer, was more to the point: "No comment." One does not need to be a student of rock history to imagine what the Beatles really thought about what their leader was doing, where he was going, and what was happening to their band.

Like my trek downtown to get the double *White Album*, I did the same for *Two Virgins*. I called Capitol Records and found out the delivery date, and I called that same day to find out when the truck was leaving for Sam's. There I was again, within a week, in the alley watching the truck pull up and unload the box. I knew that John and Yoko were naked on the cover. I knew that the album featured their all-night recording session, which had culminated in their making love for the first time at dawn. The box was carried into the store and put

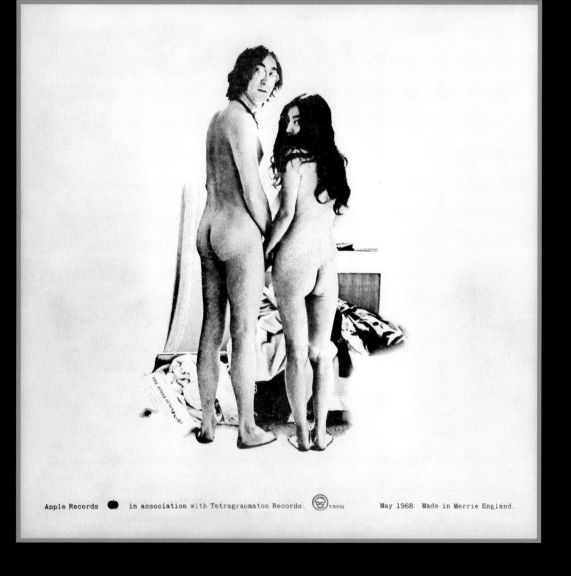

Apple Records ● in association with Tetragrammaton Records ⬤ T-5001 May 1968. Made in Merrie England.

on the floor. It was opened with the usual sight of me peering over the shoulder of one of Sam's employee. I saw the cover for the first time. WOW! I got the first album and raced to the cash register, too excited and distracted to be bothered by the sound of the police confiscating the rest of the albums.

Immediately upon its release, controversy ensued. Capitol Records and EMI would not distribute it. Instead, John managed to get a small label in the States, Tetragrammaton Records, to sign on. Labeled pornographic throughout the UK and North America, police and customs authorities were grabbing copies as soon as they arrived. I managed to get one of the first copies before they were taken off the market. Sometime later, the two virgins were covered in brown paper with only their faces showing through a cutout.

I now had two major releases to be enthralled with and they were as divergent as could be. *Two Virgins* made clear to me what was going on with John and Yoko. It was a romp of experimentation, fun, tenderness, and insanity. Everyone I knew hated it. Not me. It did not take long for this album too to get dirty. In fact it was easier because the cover was absorbent white paper whereas the double *White Album* was glossy. I walked around with—and played—this album constantly.

I lost myself in the music the way I lost myself in many of the heroes I idolized at the time, who included great actors like Richard Burton, Peter Sellers, Peter O'Toole, and Marlon Brando. Each of my heroes projected strong and daring personas that I tried to emulate. But there were three specifically that I worshipped above all others.

Canadian prime minister
Pierre Trudeau was brilliant,
principled, and contrary.
He showed young people
the different cultures
of the world and the
promise each of us had
to fulfill. Jerry Lewis was
the opposite: outlandish,
desperate, and gutsy. But of
course, no one could touch the
Beatles, and especially John.

In the late summer of 1968,
I was watching a promo for
the upcoming Jerry Lewis
Muscular Dystrophy
Telethon. So captivated
was I by that in-your-
face funny man that my
parents sometimes
had to stop me from
watching television
because I would get
an asthma attack
from laughing so
hard. The telethon

was coming up that Labor Day. I had a brainstorm. I called New York City information and asked for the Americana Hotel where the show was broadcast from in those days. I asked for the Muscular Dystrophy Association's pressroom. I was instantly connected, and amidst the sound of typing and talking, a man with a thick accent answered, "Moose Delgado here." I put on my deepest voice and said, "Hi. I'm from Canadian News and want to cover the telethon for Canada." "What's your name?" he asked abruptly. "There'll be a press pass for you at the front desk."

I booked a flight with American Airlines with the money I had saved, and on the afternoon of the telethon I matter-of-factly told my parents that I was going to New York to see Jerry Lewis. A taxi pulled into our driveway and beeped. My parents were stunned as I walked out of the house and into my first cab ride. I think I heard screaming as the cab took off. Alone, at fourteen, I rode to the Toronto airport and got on the plane. My first visit to New York City was at night. I saw all the tall buildings that I had seen on TV, in the movies, and in the magazines. I was too excited to be afraid.

Entering the hotel I saw a crowd of people trying to get into the ballroom theatre. On the left I saw red satin ropes that created a line up to a desk with a sign that said "VIP." I went there and saw Johnny Carson enter to applause. When I got to the desk I told the person there my name. She looked in a box and handed me a ticket and a badge. I walked in, past the crowds and security, and walked right up to the front row and sat down in the middle.

I sat there all night and took pictures. Emboldened by my role of press man, I walked right up to Jerry and snapped away as he was

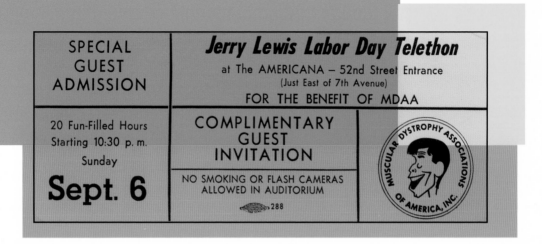

SPECIAL
GUEST
ADMISSION

Jerry Lewis Labor Day Telethon

at The AMERICANA — 52nd Street Entrance
(Just East of 7th Avenue)

FOR THE BENEFIT OF MDAA

20 Fun-Filled Hours
Starting 10:30 p. m.
Sunday

Sept. 6

COMPLIMENTARY
GUEST
INVITATION

NO SMOKING OR FLASH CAMERAS
ALLOWED IN AUDITORIUM

288

MUSCULAR DYSTROPHY ASSOCIATIONS
OF AMERICA, INC.

talking on a microphone. It did not dawn on me that this was live and I was between him and the camera and millions of viewers. At a certain point in the evening, a blond kid a few years older than me asked me during a break who I was and why I was there. I told him that I was a huge fan of Jerry Lewis and flew down from Toronto to see the show. "You want me to introduce you to my Dad?" he asked. "Sure," I said. "Hey Dad," the kid called. Jerry Lewis walked down the stairs. "This kid came from Toronto to see you." "Hi," Jerry Lewis said to me in that familiar trebly tone and proceeded to walk right back up the stairs. I loved it. Classic Jerry Lewis. I realized that day how easy it was to follow my dreams. I came back to Toronto to the shock of my parents, which changed to amazement when the photos were developed.

But, still, the largest part of my self-definition at the time was my devotion to the Beatles. I never missed an opportunity to tell any new friend how great they were and how much I knew about them. I used to go to parties with my record collection and no matter what was on

the stereo at the time, I would confidently walk up, take it off, and put one Beatles album or another on the turntable. I would do that in the middle of another record being played to hoots and shouts. It got to the point that I was told that if I kept doing that I would not be invited to parties anymore.

It was sometime before the double *White Album* that I followed John and got granny glasses. The fact that John was sporting the simple round lenses made me feel more confident to let the world know that I could not see very well either. It made me more like him—witty, cocky, smart. John's new look was heralded in *Rolling Stone* magazine's premier issue in November 1967. There he was on the cover brandishing a helmet and British Army standard spectacles, from a still from Richard Lester's black comedy *How I Won the War*. Lester was the director of *A Hard Day's Night* and *Help!* and convinced John to play a spaced-out British soldier. With no Beatle project underway and no concert tour, John accepted. The end of touring saw each member of the Beatles pursuing personal ventures. Paul composed the soundtrack to a British film, *The Family Way*. George grew a beard, studied eastern philosophy, and hung out with Indian musicians. Ringo pursued an acting career and sported a full and drooping moustache. The Beatles were starting to think about the unthinkable—individual lives.

In addition to John's glasses, I began wearing clothes like the Beatles. My brother was more stylish and had the trendier clothes. I would wait for him to leave for school first so I could swap what I was wearing for his latest buy. He caught on to me pretty soon when he would see me strutting about with his shirt. I started walking around in loose white pants, white peasant shirts, and sandals. Becoming more and more discerning in my selection of clothes, I managed to emulate the Beatles in hair, spectacles, clothes, and swagger.

The year 1969 started with a bang. Word spread that the Beatles were having financial difficulty, and John was quoted lamenting the sorry state of Apple, saying, "All four of us will be broke in six months," if the present spending at their company continued. Rumors of rancor, fistfights, tension with Yoko, and the breakup of the world's biggest band were everywhere. *Rolling Stone* magazine printed an article in its February 15, 1969, edition with this headline:

APPLE IS ALIVE AND HEALTHY
BEATLES SPLIT RUMORS UNTRUE

The music scene at the beginning of the new year was flourishing. January started with the release of Neil Young's and Led Zeppelin's debut albums. Bob Dylan's *Nashville Skyline*, Sly & the Family Stone's *Stand!* with the classic hit "I Want to Take You Higher." The Who were performing live concerts of their upcoming *Tommy*. Santana, Moody Blues, Frank Zappa, Creedence Clearwater Revival, Johnny Cash, Crosby, Stills & Nash, and the Doors were overwhelming the radio waves with their classic recordings. There was talk that the Beatles were filming and rehearsing their next album and that it would culminate with a performance that would be recorded live somewhere exotic. But the talk of infighting continued unabated.

On March 12, 1969, headlines around the world announced that Paul McCartney had married Linda Eastman at a simple civil ceremony at Marylebone Register Office in London. None of his Beatle brothers was there. Eight days later, John Lennon married Yoko Ono at a ceremony in Gibraltar. None of his Beatle brothers were there. These two events, in the context of the rumors of financial turmoil, an imminent breakup, the *Two Virgins* album, John's drug bust in October 1968, and George's in March 1969, made it clear to all the world that the loveable mop-tops were no more. Both John and later George, though no strangers to drugs at the time, were victims nevertheless of a zealous Scotland Yard drug squad detective, Sgt. Norman Pilcher, who was responsible for busting famous English performers like Mick Jagger, Eric Clapton, and Donovan. Bagging a Beatle would be on the top of his list. (Ultimately, Sgt. Pilcher would be imprisoned for his conduct on the drug squad.) For detractors of the Beatles, and specifically John, this was proof of their degenerate influence

on young people. The Beatles were constantly in a fishbowl and the controversies surrounding their personal lives were intolerably intrusive. Whether they were breaking up or not, John, Paul, George, and Ringo had tired of being Beatles. They were all desperate for changes artistically and personally.

Fuelled by their bizarre image and branded as sexual deviants, John and Yoko decided to make their honeymoon a media event. They had already been hounded by the press, which was always looking for a scandal. Nudity and perversion were particularly effective at selling papers. And so, Mr. and Mrs. Lennon invited the media to join them in bed at the Amsterdam Hilton between March 25 and 31, 1969, every day starting at 9:00 A.M. and ending at 9:00 P.M.

Undoubtedly the press was expecting to see John and Yoko in full naked embrace. Instead, they were greeted by the two in pajamas with signs that the now fully bearded John had drawn: "Hair Peace," "Bed Peace." All they would talk about was world peace. It was a circus. It was bizarre. And it was brilliant. As savvy as any Madison Avenue marketer, John and Yoko manipulated their fame and infamy for the purposes of spreading a simple message. Increasingly unshackling himself from the Beatles machine and image expectations, John, intellectually egged on and inspired by Yoko, was free to talk about the politics of war and peace. Brian Epstein would have shut him down in an instant. Now he was answerable to no one other than his conscience and his tutor, Yoko Ono.

The news reports of this event were mixed into images of body bags of young Americans being carried onto planes in Vietnam, terrorism in the Middle East, and hunger in Africa. For the first time,

the power of rock was being used for an ulterior, altruistic purpose.
With Yoko as his muse and partner, John Lennon was coming of age;
he was stepping out on the world stage as a political and social leader
and as a spokesman for young people everywhere. I was enthralled,
proud, and fascinated. If the Beatles were the best, John was even
better. This was a time to be counted amongst Beatle fans. Kids were
gravitating away from them as a predominant musical influence. John
was taking a stand and being attacked. Loyalty was needed, and I was
ready for the assignment. We were no longer just listening to music
and going to concerts. We were about to change the world. That is
when I decided to express my loyalty directly to John. I wrote him a
letter at Apple in London. I told him I was his biggest fan and how
much I loved the double *White Album* and *Two Virgins* too. I drew a picture of earth, with the North and South America side showing, and a red arrow pointing at Toronto. "This is where I live," I noted on the side. "He would think that was funny," I thought and who knows, he might write me back.

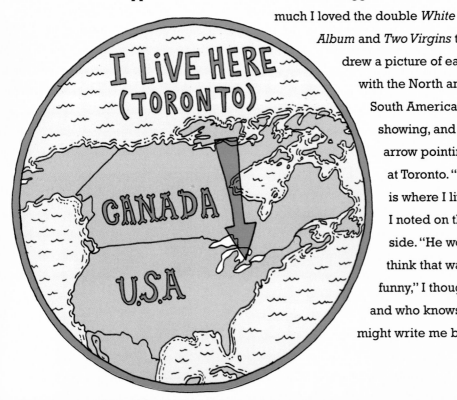

Steve was driving my cousin Larry and me to a movie one night in April 1969. I was in the back seat with the boom box. For about a week CHUM (the premier Toronto rock station) was announcing that they were going to play the Beatles' new single "Get Back/Don't Let Me Down" at a specific time on a specific night. For some reason, CHUM claimed to have world premier rights to Beatle songs. I would not miss that for anything, and held onto the radio until the deejay said what I was waiting for: "Here it is. The Beatles. 'Get Back' and 'Don't Let Me Down.' A CHUM world premier." The feeling of hearing those two songs for the first time has stayed with me. Within seconds of the opening strum, Ringo's drum beat and staccato cymbals set the stage for Paul. "Jo Jo was a man who thought he was a loner but he knew it couldn't last." Throughout the song, maybe six or seven times, a prerecorded whispered announcement layered over the music proclaimed, "A CHUM world premier." Barely five months ago the Beatles had given us the double *White Album*. "Don't Let Me Down" was segued by another "This is a CHUM world premier." My God, I loved that song from the instant John cried out his love for Yoko. I was in heaven.

CHUM was the kind of station that would play a side of an album uninterrupted by commercials. The deejays were trippy, some brighter than others, and the ads were for things like the Toronto Free Drug Clinic and hip clothing stores. It was the kind of station where you could call the deejay up and he would answer your call on air while spinning a record. CHUM-FM's AM sister station had a much broader and bigger listening audience. It is hard to believe, but back then, most people listened to AM radio. FM was for a specialized

audience. CHUM-FM became a rock station in 1968. Before then it was strictly classical. This was the beginning of the overpowering impact rock would have on radio demographics throughout North America. Once a week, CHUM would list its "CHUM chart," which would be published in newspapers and promoted on the radio. You could not wait for the new CHUM chart to see how your favorite song was doing. On Saturday, May 24, 1969, I took my weekly pilgrimage to Sam's to check out the latest list of hit songs. This was that week's CHUM chart:

chum 30

This week	Title	Artist	Dist.	Last week
1	Get Back / Don't Let Me Down	Beatles	Capitol	1
2	Hair	Cowsills	Quality	3
3	Love (Can Make You Happy)	Mercy	Columbia	8
4	Goodbye	Mary Hopkin	Capitol	10
5	Hawaii Five O	Ventures	London	2
6	The Boxer	Simon & Garfunkel	Columbia	6
7	More Today Than Yesterday	Spiral Staircase	Columbia	7
8	Gitarzan	Ray Stevens	London	5
9	Bad Moon Rising	Creedence Clearwater	Musimart	21
10	Oh Happy Day	Edwin Hawkin Singers	Quality	24
11	In The Ghetto	Elvis Presley	RCA	28
12	Nothing But Heartaches	Flirtations	London	4
13	Too Busy Thinkin'	Marvin Gaye	Phonodisc	20
14	Heather Honey	Tommy Roe	Polydor	25
15	Happy Heart	Andy Williams	Columbia	15
16	The River Is Wide	Grassroots	RCA	16
17	Chokin' Kind	Joe Simon	London	18
18	Morning Girl	Neon Philharmonic	Warner Brothers	19
19	Grazing In The Grass	Friends Of Distinction	RCA	23
20	Where's The Playground Susie	Glen Campbell	Capitol	26
21	Atlantis	Donovan	Columbia	—
22	Honey Love	Martha & Vandellas	Phonodisc	22
23	Sweet Cherry Wine	Tommy James	Allied	9
24	Medicine Man	Buchanan Brothers	Compo	30
25	Theme From Romeo and Juliet	Henry Mancini	RCA	—
26	It's Your Thing	Isley Brothers	Quality	13
27	Day Is Done	Peter Paul & Mary	Warner Brothers	—
28	I've Been Hurt	Bill Deal	Quality	—
29	Truck Stop	Jerry Smith	Polydor	—
30	Everyday With You Girl	Classics IV	London	—

chum chargers

No Matter What Sign You Are	Supremes
Too Experienced	Eddie Lovette
Baby I Love You	Andy Kim

chum albums

Blood Sweat & Tears	Blood Sweat & Tears
The First Edition '69	The First Edition
My Way	Frank Sinatra

Whenever there was a new Beatle single, I would track it with NASA-like precision. How many weeks was it on the charts? Was there movement? What conspirator was trying to overtake them? On that Saturday the Beatles were in the number one position with "Get Back/Don't Let Me Down." Creedence Clearwater Revival was breathing down their necks and moving fast with "Bad Moon Rising" as was Elvis' biggest hit in years, "In the Ghetto." Moving fast as well was Apple recording artist Mary Hopkin with her follow-up to "Those Were the Days," Paul McCartney's "Goodbye." I was happy and the Beatles were in good shape. I had no idea that Saturday afternoon, as I walked along Toronto's busy Yonge Street eating a hot dog, that just like the lyric from "Aquarius," from the popular Broadway show *Hair*, the moon was in the seventh house and Jupiter was aligning with Mars.

you hear more

WORLD PREMIERS

on chum than on any other radio station in the world . . .

The Beatles, Tommy James, The Supremes, Dionne Warwick, Simon & Garfunkel, Mary Hopkin

●

when the big sounds break, you'll hear them first on chum.

cover:
MORE MINUTES OF THE MUSIC YOU WANT TO HEAR ON THE BRIAN SKINNER SHOW ON CHUM 11 P.M. - 5 A.M.

I MET THE WALRUS

I was taking a shower on Sunday evening, May 25, 1969. Steve had a portable radio with large, built-in speakers that he let me use from time to time. It was blaring away on CHUM-FM. I do not remember what was playing when that particular deejay ended the cut with this statement: "Someone called to say he spotted John and Yoko at the Toronto airport. Wild news if it's true. We'll try to check it out. In the meantime, let's have some 'Rain.'" Ringo's famous staccato drum beats pounded away and John's song began. An electric shock went up my spine.

It was the fastest shower I ever had. I don't remember telling anyone what I just heard. Dried and clean, I went straight to my room. Without thinking, I picked up the phone and called all the high-end Toronto hotels. I called the Royal York Hotel first. "Hello, is John Lennon there?" I asked. "One moment please," was the reply. I waited. "There is no John Lennon here." I then called the King Edward Hotel. That was where the Beatles had stayed when they came to town on their last tour in 1966. "May I speak to John Lennon please?" The clerk hung up on me. With such an abrupt reaction, he must be there, I thought. "I should look like a reporter," I told myself.

I took out my deep purple, quadruple-breasted jacket that I wore for my sister's wedding. My brother-in-law, Haim had made me a dark

green suede bag that I carried over my shoulder. On it, with black magic marker, I had written:

*The Beatles
Pierre Trudeau
Jerry Lewis*

In the bag I put my *Two Virgins* album, a small pad of paper, and a pen. I would be a reporter. But I needed camera equipment to perfect the ruse. I borrowed my sister's Kodak Brownie, a fairly cheap model that wasn't very impressive, but it would have to do. Steve had a new Super 8 camera. I snuck into his closet and took it. I was ready. I would not go to school the next day. I would get on the bus and find John Lennon.

My alarm was set for 6:00 A.M. but I woke up earlier. There was never any real plotting or doubt about what I was going to do. It was as if I was drawn to the King Edward Hotel. My hero might be in town. How could I pass that up? Not meet John? Just let him drift through without saying a word? It was as if he answered my letter, looked at the map I drew with the arrow pointing at Toronto, and got on a plane. My mind and my life had been so consumed by the Beatles that it really seemed like fate. What would he look like? Would I get to talk to him? Oh, the secrets he could tell me, about Beatle songs, about the world. I had to tell him how much I loved the double *White Album*. And Yoko! Would I meet her too? She should know that I stood up for her and played *Two Virgins* for everyone. All these thoughts were racing through my mind as I rode the bus all the way downtown.

It was still pretty early when I got there at about 6:30. Rush hour had not even begun. I nonchalantly walked through the regal stone doorway of the King Edward Hotel, into the grand lobby, and towards the elevators. Pressing the top floor button seemed like the right thing to do. I got out and just started knocking on doors. Most of my victims were awakened and went right back to sleep after I politely apologized. One room had a tray on the floor in the hall, the remnants of last night's room service. A bottle of soy sauce was lying on its side amidst the dirty plates and uneaten food. "He must be here!" My innocent fourteen-year-old mind presumed that Yoko's influence with John included his seasonings. Knocking with pride and a sense of accomplishment, I was taken aback when a man with a large belly held in place by a white cotton sleeveless undershirt and striped boxers opened the door and yelled at me. Clearly not John Lennon.

It did not deter me, though, and I kept knocking on doors. I must have completed three or four floors when a grandmotherly maid with white hair tied in a bun walked up to me. My nerves dissipated when she bent down and whispered in my ear with her Scottish accent, "You looking for the Beatle?" "I am," I said. "He's in room 869. Don't tell anyone I told you, now." With that she patted me on the back as I swiftly made my way to the stairs. Once on the eighth floor, I turned the corner of the corridor, looking at the numbers, until I saw at the very end a little girl lying on her stomach on the floor in front of a closed door, coloring. I recognized her immediately. It was Yoko's five-year-old daughter, Kyoko, from her previous marriage to American filmmaker Tony Cox.

Walking up to her, I asked if her mommy was in the room. She said yes and continued to color. My heart beat fast. For the first time I began to question whether I had the nerve to go in. What if he didn't like me and sent me away? How crushing would that be? About three or four minutes must have passed by when a television cameraman and a reporter abruptly pushed me aside. The reporter knocked on the door. It opened a couple of inches. He mentioned the broadcaster's name, the door opened a bit more, and the two were sucked into the chamber with a thump.

I took a deep breath. I looked around. I waited about ten more minutes, slung the Brownie around my neck, took another deep breath, and knocked. "Canadian News." The door opened in the same manner as before. Then it opened more. I marched right in staring at my feet as I followed the carpet of the suite into the living room. If I made eye contact I was afraid I would be thrown out. The base of a tripod was

where I decided to sit down. When I slowly looked up, there about four feet in front of me sat John Lennon and Yoko Ono.

They were in the middle of an interview and no one stopped me or said anything. John looked down and smiled. It did not faze him. He was dressed all in white—white loose cotton pants and a short-sleeved tight-fitted shirt. Yoko had a black sweater on with white pants and white stockings. John was barefoot and had a big bushy beard, exactly like the *Abbey Road* cover. Right then and there I knew that my life would be changed forever.

John and Yoko were giving interviews to the few Canadian reporters who'd been invited into the suite. They were talking about peace and their plans for a bigger and better bed-in for peace in

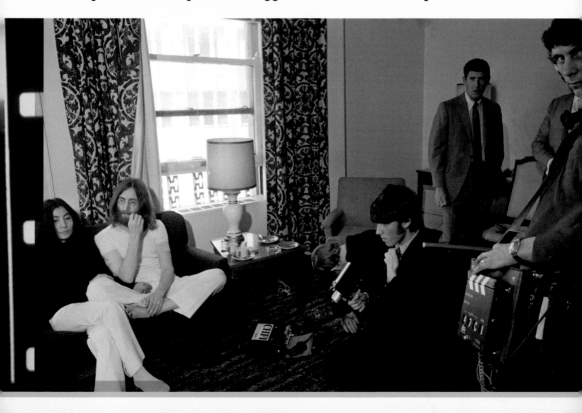

Montreal. The Lennons had almost flown into the U.S., but John's earlier drug conviction posed problems. Canada, with its proximity to the American media, was the next best thing. They were sitting on a couch in front of two bright windows. John was cross-legged and tugged at his beard often. There were several people in the room, but not too many. One fellow grimaced at me and so I thought I should play my part. I took the Super 8 camera out of my bag and started pretending I was a photographer. I did not know if there was film in it and I did not know how to operate it. It was basically a prop. I bounded up to John and Yoko, placed it to my eye and played with the zoom button. John alternated between smiling and frowning as I approached his face. He was drumming his hands on his legs. I pointed there. He played

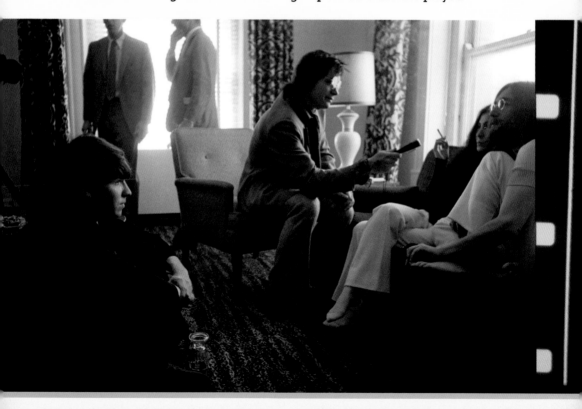

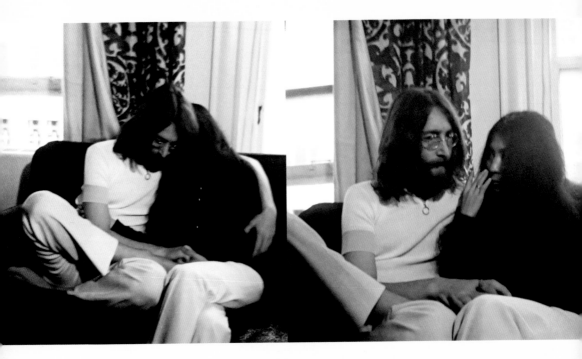

with his feet. I focused on that. Yoko was beside him, held lovingly and close. I remember thinking that she was beautiful. The photos I had seen had not done her justice.

Someone coughed behind me, and I realized that I was blocking the real cameraman. John laughed as I got out of the way and sat down reverentially. No one seemed to take the initiative to remove me and certainly John gave no direction to do that. John would glance over at me occasionally, smile, and tug on his beard. Clearly used to an audience of wide-eyed admirers, he carried on with interviews and talking to Yoko in intervals. They would touch each other affectionately and whisper to each other constantly. I sat there watching all this for about an hour when a tall, long-haired man with spectacles and a mustache, dressed in a double-breasted black suit and multicolored tie,

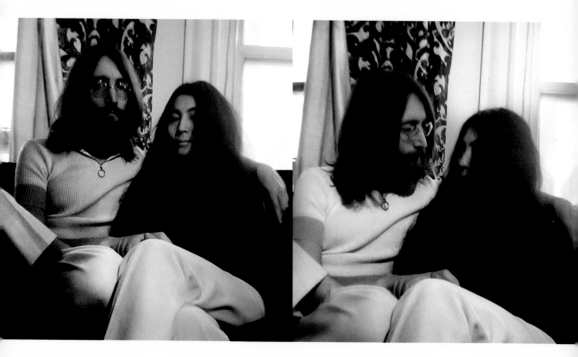

came into the room and announced to the five or six people present: "I beg your pardon but you all will have to leave now. Mr. and Mrs. Lennon have to go to customs for a chat." It was Derek Taylor, the public relations man for Apple. He was handsome, dignified, and very British.

The few reporters and photographers there started to gather up their note pads and equipment. I jumped up from the floor to where John and Yoko were sitting. He was about to get up. I took out my copy of *Two Virgins* and my hero spoke to me for the first time: "How did you get that? I thought the Mounties had come in on horses and took them all." I caught Yoko's attention as I told him how I had been at Sam's and got it out of the box. "Who is Sam?" he asked. As I explained and went on to tell him how diligent I was in getting the record, he took a marker and drew in the top left corner of the album:

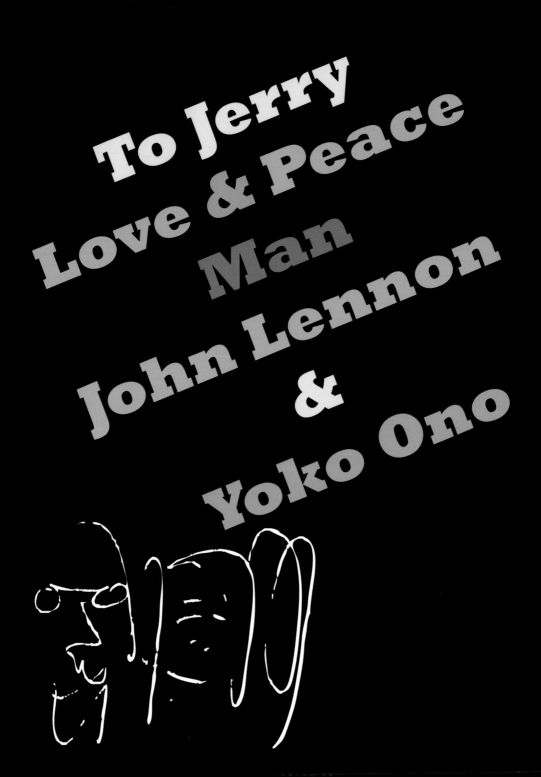

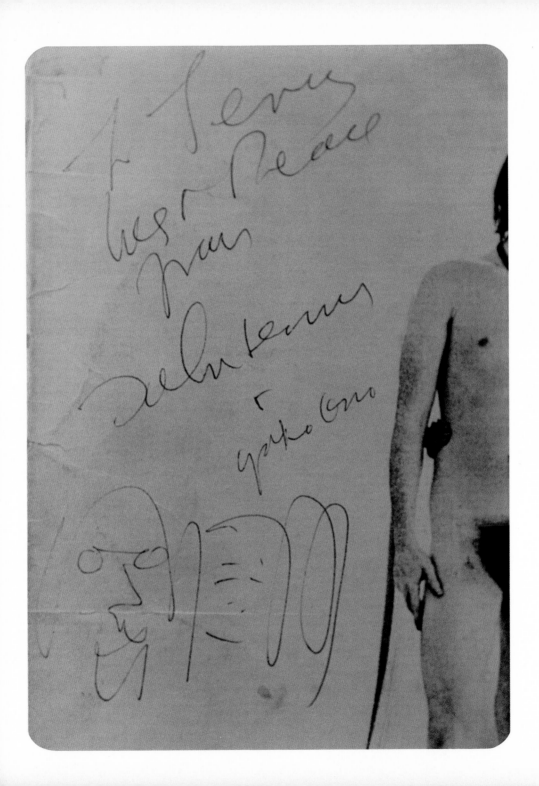

He then drew a caricature of himself and Yoko. While I was witnessing this monumental moment in my life, I took everything in, thinking it was to be my last encounter with my hero. There was a pack of Gitanes, the powerful French cigarettes, next to a glass ashtray full of butts. Next to the cigarettes was a package of spearmint gum. I noticed how trim John's toenails were. I looked at his long fingers with calluses on them. These were the fingers that plucked away on "Dear Prudence" and "Julia," I thought.

Yoko offered to sign too and I was elated. There I was watching my hero and his new bride personalize my album. The irony of it being a naked photo of the two of them escaped me at the time. I was so innocent and they were so carefree. A photographer for a local newspaper took out his camera and immortalized the scene of the megastar signing the record while his fan witnessed the life-altering moment. "Thanks so much, John," I said. "Pleasure, man," he replied. Mr. and Mrs. Lennon got up from the couch and disappeared into the suite. All the others were gone and I was alone in the room. I took my time pretending to collect my things.

I dawdled for as long as I could and then decided to leave the suite by a circuitous route and go past the bedroom. There was Beatle John Lennon, alone, trying to push a large sea chest onto the bed. "Give me a hand, lad," he said, huffing and puffing. I bounded into the room and grasped the chest

along with my hero. Our noses were inches away from each other. He was taller and thinner than I thought and had a clean, almost antiseptic smell about him. Suddenly an inspiration flashed into my mind. We were still pushing that heavy chest when I said, looking directly into his eyes, "John, can I come back later and tape an interview with you about peace and stuff and let kids listen to it?" As the chest landed on the bed he said, "Great idea! Great." Standing up straight, he shouted, "Yoko, Derek!" They both arrived within seconds to see what the fuss was about, no doubt surprised to see that the kid was still there. "Kid's got a great idea. He'll come back later and tape an interview," he said. "We'll talk about peace and he'll take it to his school, let kids hear it. It's great! It's why we're doing this!" Yoko voiced her approval and told Derek to set it up and show me out. I waved good-bye to John and thanked him. "Come back at 6:00, then," he told me paternally as the door shut behind me. I walked a few feet down the hall. It was quiet and empty. I stopped suddenly and took a deep breath. "My God," I thought. Transformed and stunned by what I had accomplished, I exited the King Edward Hotel floating on air.

The first person I needed to see was my mother. I wanted to tell her about the amazing thing that had just happened. There I was, on the bus going back to north Toronto. It was about 11:00 A.M. People were carrying on their business oblivious to the fact that I had found, met, and talked to the most important person on earth. My smile was serene, but purposeful. I stepped off the bus at the corner of Bathurst Street and Eglinton Avenue, the epicenter of Jewish Toronto. Bakeries, creameries, religious shops. Bubbies, yentas, and busy men abounded. My Aunt Chana slaved away at Village Kosher Meat Market, a small

shop that was always busy and packed with mothers buying poultry, eggs, and prepared foods. Aunt Chana worked all day in the back, grinding the stuffing for kishke and making blintzes and kreplach. She was one of three sisters, out of six, who had survived the concentration camp. My mother would help out here and there by working at the counter. A white-haired butcher with a neatly trimmed mustache owned the meat market.

My mother screamed when I walked in. "Why aren't you at school? What happened? Are you sick?" She barraged me with worry and anxiety. And then the flood began: "Ma, I found John Lennon! I was in his room. He's here! In Toronto! He's so great! Yoko was there too! I talked to him. I'm going back later! JOHN LENNON, Ma. Can you believe it!! Here, look, he signed my album." My mother gasped as I spit out those phrases in that small shop amidst a few customers looking for giblets and chicken shmaltze. It caused such a scene that the butcher came running out from the back and pulled us away from the customers, and into his office that was filled with greasy invoices and huge bags of kosher salts.

"What's wrong with your boy, Judy? Is he sick? What's going on?" he asked. My mother was speechless as I began my adrenaline-fueled recitation of the greatest story ever told. The butcher stood there, looking prim and proper, his bowtie neatly positioned at the top of the bloodied apron that hung from his upper chest to his ankles. He said nothing until I pulled out my now precious *Two Virgins* album. "And look!" I said holding my artifact high in the air with pride and flair. "He signed it. Yoko too!"

The circumspect butcher made a high-pitched, very short squeal. His head spun around for fear of customers, or worse, the rabbinical

inspector, walking by and witnessing John and Yoko's genitalia. "Put that away right now. It's filth," he said in an uncomfortable whisper as he pushed the album into my bag. Indignant I looked up at a girlie calendar he'd hung over his desk next to a poster for the United Jewish Way. "What do you call that?" I asked, pointing at a voluptuous woman in fancy lingerie. The butcher answered with composure and confidence. "That is art. This," he said with a look of disgust on his face, "is pornography!"

I exploded. My mother turned to him and told him she would deal with it. He went to the front with a huff. She took me right to the back where my aunt was squishing stuffing into stomach casing. When my aunt saw me, she too asked what was wrong and if I was sick. "Jerry, what is going on? What are you doing?" my mother asked. She was worried and confused. She probably thought I was on drugs. None of what I was saying made

sense to her. "Ma, I really met him," I answered calmer now and cognizant of the turmoil I had caused. "John Lennon. I met him. And I'm going to see him again later." "Jereleh," my mother said softly, stroking my hair. "Go to school. Don't do anything meshugah. Please. Go to school." "Okay, Ma. I'll go to school," I told her. Walking out, I passed the butcher who was talking to a customer from behind the counter. I gave him a defiant smirk, which was met with a harrumph. My anger was tempered by my knowledge that I was special. I was anointed and, on that day, something more than Jerry Levitan of Searle Avenue.

Eglinton was on the boundary of the suburb. I had only three major intersections to get to my neighborhood. I took my mother's advice and went to school—but not to study math; rather, to spread the word. It was lunchtime and the front of Dufferin Heights Junior High School was populated with a couple hundred or so kids milling about, smoking, necking, running, strutting, and gossiping. Girls with white micro-miniskirts, orange leggings, and pink tops. Guys with bad long hair, green-tinted octagonal sunglasses, baseball gloves, and gum. I did not smoke, did not drink, and had never seen drugs up close let alone tried any. I walked studiously into the crowd, and the kids seemed to notice that I had something grand to share with them because they all parted like the Red Sea and a hush came over them. I really do remember it that way.

I took out my *Two Virgins* album and began to tell the story with shortness of breath but with the comfort that I spoke the truth and was telling a tale of profound importance to my compatriots. It was still only a rumor that John was in town. The media had not circulated the story yet. That came later. And what I had to tell was incredible to

say the least. The Beatles were the biggest thing ever and everyone
knew it whether they preferred the Stones or the Bee Gees or
whoever. I was at the center of a hundred or so kids, showing my
album and regaling them of my encounter with our king. I had their
fixed attention and the amazed ones tried to take my album to have a
closer look. But I would not let them touch it.

"And I'm going back again at 6:00 to interview him." With that
one of the guys shouted in derision, "Yeah, right. That's bullshit.
You're bullshit!" He led most of the "testosterites" away, but the
girls and the more sensitive fellows stayed with me. "You really saw
him?" "He said you could come back?" "What did he look like?"
"Was Yoko nice?" "Is he going to live here?" "Are the other Beatles
coming?" "Can we come too?" All of those questions and more
were hurled at me as if I was the president in a scrum after a summit
with world leaders. "He only invited me, and it's for a special
purpose," I told them. For some reason I didn't get much flak for
that comment, which has always surprised me. Somehow they
each understood.

The crowd quieted down as the tall and dark Mr. Davis, the
disciplinary vice principal, made his way through the crowd,
plucking smokes from mouths and sternly viewing the dynamic. The
commotion was reported to the powers that be that something was
up and he was going to get to the bottom of it. Kids started to move
away and form a circle farther away as he focused on me and made
his approach. A couple of teachers came out too because word was
spreading fast. Mr. Davis was the kind of vice principal you were
sent to if you were a troublemaker. He did not speak much, even in
assemblies. He was mysterious and feared. I was not a troublemaker

fact, quite the opposite. I was a mediocre student, not athletic at all, and probably had never registered on Mr. Davis' radar. I gulped as he approached.

"What is all this about?" he said in a quiet but firm way. "Sir, John Lennon. You know the Beatle? He is in town. I found him and met him. And he is letting me come back again, later today." One of my friends motioned his finger across his neck and looked up to the sky. I took out *Two Virgins* and showed him the autograph. The crowd moved closer. The school bell rang. Lunch was over. "Back to your classes now," he shouted and almost everyone complied except for a few malingerers. The mean vice principal bent down and closely scrutinized my eyes to check for dilation. I did not vary from my tale but I was clearly "under the influence." And then he said something incredible, something that probably no other rambling teenager had ever heard from a disciplinary figure at school. "Take the day off," he said, patting me on the back. "Go home." This was a smart man. He was dealing with either a kid on drugs or a truth teller, or worse, a rabble-rouser. Either way, I was disrupting the school and he knew we'd all be better off if I left the school grounds. What a call.

I started walking home. It was only 1:00 P.M. and I felt as though I had lived a lifetime that morning. I was barely a half a mile away when Danny chased after me. Danny was the hippest kid I knew. In sixth grade he brought Bob Dylan albums to our English class. Our teacher was a nerdy, bald, portly man with bad breath as I recall, but he was genuinely interested in what kids were influenced by. He would often show us films and talk about music rather than books. I would rant about the Beatles and one day Danny challenged my

heroes' stature with the poetry of the upstart Dylan.

Danny was also the first kid I knew who was into Frank Zappa and the Mothers of Invention. I liked them, too, but Zappa, his music and his in-your-face attitude was quite imposing to me. Curiously, John Lennon would say the same thing when he performed with Zappa and the Mothers for the first time in June 1971. Danny liked to goad me by walking around with Zappa's *We're Only in It for the Money*. It came out in 1968 and was a sarcastic take on *Sgt. Pepper*, right down to the cover art that parodied the Beatles with smashed watermelons instead of flowers.

I was a bit intimidated by Danny because deep down I knew that he was more hip and intelligent than most of the other kids. He also was a bit of a stoner. "I believe you, Jerry," he said, stopping me dead in my tracks. "Here. Give him this when you see him later." Danny gave me something wrapped in foil. "Sure," I replied and carried on with my walk home. My head was in the clouds thinking about what happened and what was yet to come. I passed the familiar homes and streets and approached the fenced-in hydro yard that was near my home. I reached into my pocket and opened the foil to see what Danny had given me. Inside was a thick black rectangular substance that looked like a weird piece of licorice about the size of a small candy bar. I smelled it. It did not smell like licorice. And then it dawned on me. Hashish! It must be hashish! I had never seen it before but I had heard about it. Quickly, making sure no one was watching, I tossed it into the large garbage bin by the building and ran all the way home. It was about 2:30 by now. I lay down on my bed and collapsed into an exhausted sleep.

It was as if I'd fallen asleep in a swimming pool. I was drenched when I suddenly awoke. I turned on the radio, CHUM of course, and all the deejay talked about was that John Lennon and Yoko Ono were in fact in Toronto and that we were blessed by his visit. The excitement poured through the radio waves. This would have been a big event anywhere, let alone Toronto. Even in London a Beatle sighting would be enough to lead off the evening news.

Terror gripped me. What I experienced that morning was real. I had met John Lennon. Not only that, I was going back to meet him again and the world was watching. But wait! I didn't have a tape recorder. And it was 4:00 P.M. I had to leave soon. Panic set in. I

grabbed the telephone book, looked up CHUM's number, and called. "News desk, please," I requested nervously. "CHUM news," answered the gruff voice. "Hi. My name is Jerry. I have an exclusive with John Lennon at 6:00," I said. "Yeahhhh, right," he said. But I continued, "If you send someone to the King Edward with a tape recorder you can use the interview on tonight's news." I was frantically pleading at this point. "Call up Derek Taylor at the King Edward and you can check it out." He took my number and hung up with barely a good-bye.

Within five heartbreaking minutes the phone rang. This time he was as sweet as could be. "Hi Jerry, CHUM here. We checked it out and you're scheduled for 6:00. We'll send someone with a tape recorder to the King Edward. He'll be at the bar in the main lobby at a quarter to." "Thanks so much . . . that's great!" I said. I heard him continue to talk as I hung up. I had more important things to do. Straightening my clothes took a minute as did splashing cold water on my face. The only things I took with me this time were the Brownie camera, the *Two Virgins* album, some change, and bus tickets.

Everything looked the same as I walked the six or seven blocks to the bus stop. But it was not the same. My mind felt different. The dream was continuing but somehow my eyes were wide open. Climbing aboard the Bathurst Street bus that went all the way downtown, I grabbed the same single seat I usually took. Toronto had three newspapers in those days. There was a morning, afternoon, and evening edition. The afternoon editions were out, and as I looked through the bus window I could see bold headlines above a picture of John and Yoko on the cover of every paper. "Beatle flies to Toronto, detained at airport," proclaimed the *Globe and Mail*. And at each stop people were staring

at the box and holding up papers and reading voraciously. There was pride in Toronto that day. I could see it in those faces. And I was special.

Traffic was unusually congested as the bus approached King Street. Standing impatiently at the front and holding on to the pole, I could see why. The lanes in front of the King Edward Hotel were blocked off. I asked the driver to let me out. I leaped onto the street and ran towards the hotel. Police on horses, trolleys, religious and political protesters, draft dodgers, peddlers, the Mounties, and kids—tons of kids—were all parading in front of the entrance. In the morning the setting was serene. Now it was a circus, a Beatle circus starring John and Yoko.

Police were holding back the crowd and I slipped my way into the revolving front doors. In the lounge a haggard looking man in his early thirties was having a drink, a scotch I think, and munching on peanuts. There was a reel-to-reel tape recorder in a case, at his feet. Before I could ask him if he was from CHUM, he said, "You the kid?" "Yes," I proudly replied, and I discerned, even at my young age, a look of disbelief on his face. He was one of the deejays at CHUM-FM. And he was about to play technician for a kid in the presence of the biggest rock star of all time. He gulped the remnants of his drink, grabbed his case, and said, "Let's go."

I walked again into the brass-plated elevator with the British crown embossed all over it. Time stood still as I watched the arrow above the door smoothly move from floor to floor until it hit eight. The door opened but as soon as I stepped out, two big palms pressed against my chest and forcefully pushed me back into the elevator. It was a burly cop who was stationed on the floor. The deejay flashed his ID. "He's with me," he said. "He has an interview. It's legit." The cop motioned us to get out and waived us on. As I stepped out I could see dozens of kids in the hall, roped off by the police, hoping to get a glimpse of Beatle John Lennon. One of them was a kid from school. "Jerry! Jerry! Let me in with you. Please! Please!" he begged. I shrugged my shoulders. I hardly knew him and I was not in the mood to share my good fortune.

As we turned the corner, a row of reporters and journalists sat single file on chairs facing the closed door of the suite. Most of them seemed to be American media. That was what John wanted and they were all eager to get an audience with him.

When John casually said to a British journalist in 1966 that the Beatles were more relevant to youth than Christianity, it created a worldwide backlash that resulted in record burnings and death threats. Paul McCartney gave a truthful answer as to whether he had tried LSD and it made headlines. A statement from the controversial John Lennon condemning America's involvement in Vietnam would have been a bombshell. It was as if the press were egging him on and hoping for the political Beatle to take a stand. (Years later Nixon tried to have John deported when he became even more outspoken about the Vietnam War. The U.S. government saw Lennon as such a serious

hreat that the FBI closely monitored his actions and created a file on him that was more than four hundred pages long.) It was no surprise then that they all sat there in fervent expectation.

It was a minute or two before 6:00 P.M. and strutted to the door, the deejay deferentially behind. All of them sitting there were hoping for an audience. No one had been let in. John and Yoko had been at Canadian customs for hours in the afternoon and had just recently returned to the hotel. A seasoned reporter grabbed my arm and stopped me. "Where you going, Buster?" he muttered, clearly not wanting to give up his place in the pecking order. "I have an appointment at 6:00," I said, trying to break free to the laughter of everyone there. The door opened. Derek Taylor appeared, immaculate and proper as always. "Where is the lad?" he spoke in the Queen's English. I waved and broke free from the reporter and walked by them all to gasps of astonishment.

Derek led me to a chair placed in front of an empty couch. He directed the deejay to set up his equipment. Kyoko was in the room dancing around in front of a record player that played a new Beatle single. There was no mistaking the sound and the voice of John Lennon singing in

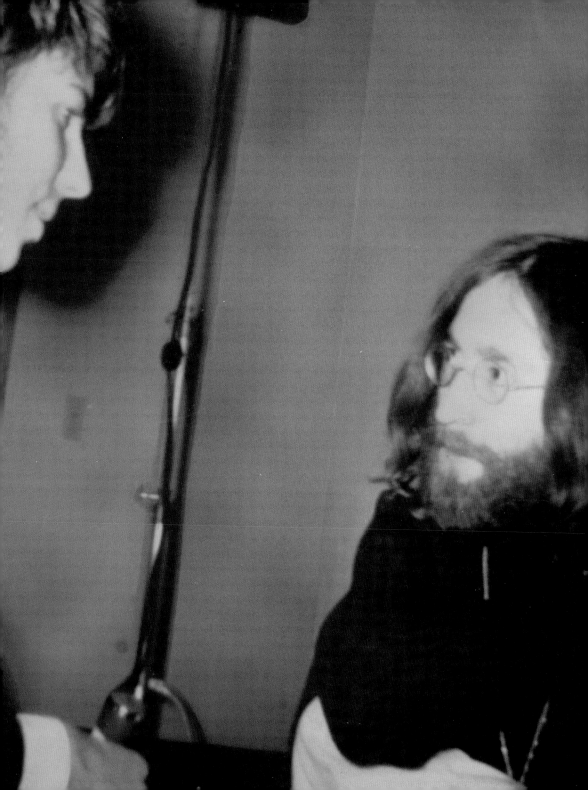

harmony with Paul McCartney. It was "The Ballad of John and Yoko." I heard this single for the first time, before anyone, in John's hotel room. It would be released within days.

"John and Yoko will be out in a few minutes. They are getting dressed," Derek told me and walked away. It was at that moment—with only the deejay, Kyoko, and I in the room—that I realized I had not prepared a single question. My panic was interrupted when John and Yoko plopped down right in front of me. His long hair had brushed my cheek. He moved fast in a bouncy, excited, childlike sort of way. "Do you want a photo then?" he said softly, eyeing the Brownie around my neck. "Sure," I answered. The deejay took the camera off my neck and said, "I'll take it." It would be weeks before I would see the photograph: John and I looking into each other's eyes, just inches away from each other.

"ASK AWAY," JOHN SAID, AND I BEGAN TO TALK.

JERRY: John, could you please tell us what the situation is with you and your entry into the United States?

JOHN: It's still sort of nowhere, you know? Like a lot of people don't want me in, you know; they think I'm gonna cause a violent revolution, which I'm not. And the others don't want me in 'cause they don't want me to cause peace either. War is big business, you know, and they like war 'cause it keeps them fat and happy, and I'm anti-war so they're trying to keep me out. But I'll get in 'cause they'll have to own up in public that they're against peace.

JOHN: Help me by helping yourselves. Just think that the militant revolutionaries . . . ask them to show you one revolution that turned out to be what it promised militantly. Take Russia, France, anywhere that had civil war. They all start out with good intentions. What they do is smash the place down then build it up again and the people who build it up hang on to it and then they become the establishment. You guys are going to be the establishment in a few years. It's not worth knocking it down 'cause it's convenient to have the rooms and the machinery. The thing is to protest, but protest nonviolently. Violence begets violence, you know, and if you run around wild you get smacked, and that's it. That's the law of the universe. And they've got all the weapons and they've got all the money and they know how to fight violence 'cause they been doing it for thousands of years, suppressing us, and the only thing they don't know about is nonviolence and humor. There's many ways of promoting peace, and we are doing it with humor and nonviolence. It's convenient for John and Yoko to stay in bed, you know. It might be convenient for other people. We just use some of our time. The position we're in is under a fishbowl, in a fishbowl. What we're doing now is having a mirror in the fishbowl and reflecting back what happens to us. That's all we can do. But there's many ways of protesting for peace. Do everything for peace. Piss for peace or smile for peace or go to school for peace or don't go to school for peace. Whatever you do, just do it for peace. Think peace and you'll get it. You've got to want it. It's up to the people. You can't blame it on the government and say "oh, they're

doing this" or "they're going to put us into war." We put them there, we allow it, and we can change it—if we really want to change it we can change it.

JERRY: Do you know anything about [Canadian prime minister Pierre] Trudeau? Are you pleased with him?

JOHN: Trudeau seems okay. I don't really know about him. I don't know if he's just another one of them. You can't really tell you know. But his image seems better than the others. His image in Britain was okay. He was swinging and he wore a leather coat, that kind of thing, so I don't know whether that's just an image. He said on the air that he'd like to meet us, but he doesn't know about his schedule. Now that's either games that he's playing or he means it. Well, we'll find out and you'll know by the time we've left here whether we saw him or not. If we saw him there's a chance he's okay, and if we don't see him, you'll know what games he's playing.

JERRY: I'm not sure what he said. I think he said that you wanted to give him acorns to plant. And he said, "I'd like to meet him but I'm not sure about planting the acorns," or something like that.

JOHN: Well, I just heard that, too, and he said he might not have time to plant the acorns. I don't know what that means, Mr. Trudeau. How much time does it take to stick your finger in the soil? You know and if he'll see us, we'll explain to him how easy it is to plant acorns.

JERRY: You know if you see him, I've met him twice personally, and ever since then I started liking him, etc., and I like him. I think if you see him and talk to him, I think maybe then you probably could work out some answers.

JOHN: Yeah.

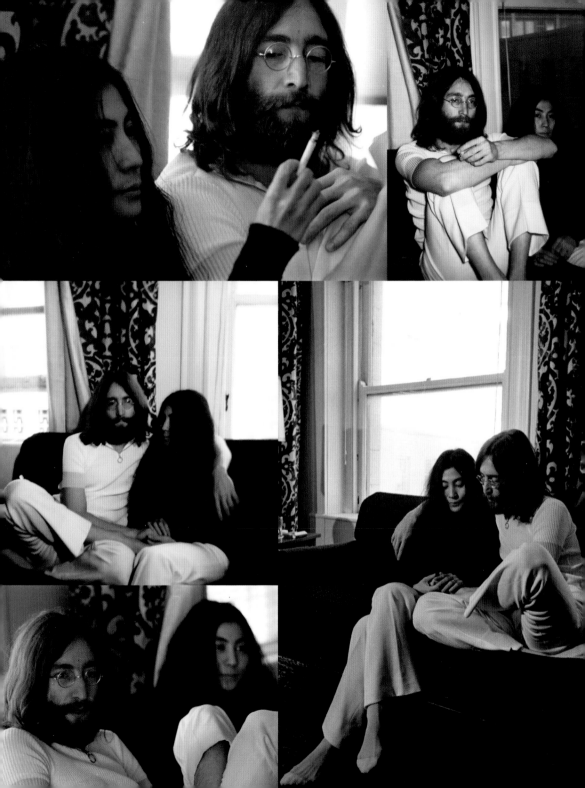

JERRY: Are you planning to stay in your bed-in for seven days in Montreal?

YOKO: Yes.

JERRY: What about Paul, Ringo, and what's his name . . .

JOHN: George.

JERRY: George [laughing], what about them, are they peaceniks also?

JOHN: Yeah, they're peaceniks also, like, we're all four individuals, and George was saying to me just before I left on this that he's with me all the way but he says he was feeling a bit guilty 'cause he wasn't coming out shouting too. He says, "I'm different from you and you've always been the loudmouth and the talker." And that's my gig. George is doing it in his own way with the musicians and the people he meets and the way he goes about his life. It's like that, you know. It's no good shouting in the street corner "I want peace," and then beating up your mate, you know. You've got to try to work your own head out and get nonviolent. It's bloody hard because we're all violent inside. We're all Hitler inside and we're all Christ inside, and it's just to try and work on the good bit of you. It's just convenient to live in peace, you know.

JERRY: Both of you produced a film called *The Rape.* Is it coming to Canada?

JOHN: We'll show it as soon as we can. If we could get some kind of visa we might show it while we're here.

JERRY: I saw when *Magical Mystery Tour* came to the O'Keefe, I was pretty much impressed and I was wondering if all four of you are planning on making any more films.

JOHN: We are. We just did a sort of documentary on the Beatles making an album, and it's amazing to see what the hell we go through [laughter]. I don't know how all this language is going to get through your school board. But it's amazing to see all the stress and strain we go through to make an album. That's a movie in itself. But to find a vehicle for four apes like us without making another *Help!* or *A Hard Day's Night* is pretty tough going. So if we come up with something we'll do it and if we don't we won't. It's just like that.

JERRY: About your album *Two Virgins*. Today after I got your signature earlier, I went to show it to my vice principal and my teachers, they saw it before and liked it very much, they get their kicks out of it, they're pretty much impressed, but there's this one guy, on my way back . . .

JOHN: Yeah.

JERRY: It was where my mother works and the butcher is there and he got very upset and started telling me, "It's filth and I feel sorry for you even to look at something like it." So I just glanced over in the corner, and I saw there was this nudie picture of this lady on a calendar.

JOHN: Yeah. Yeah.

JERRY: So I tell him, "What do you call that?" And he calls it "art."

JOHN: Oh yeah, well those people are mental, you know.

JERRY: [Laughs.]

JOHN: And there's nothing much we can do about them. They're the old generation, and we've got to try and contact with them 'cause I mean it's no good us going around saying, "We're hip" and then taking no notice of them. We've got to try and break through to them.

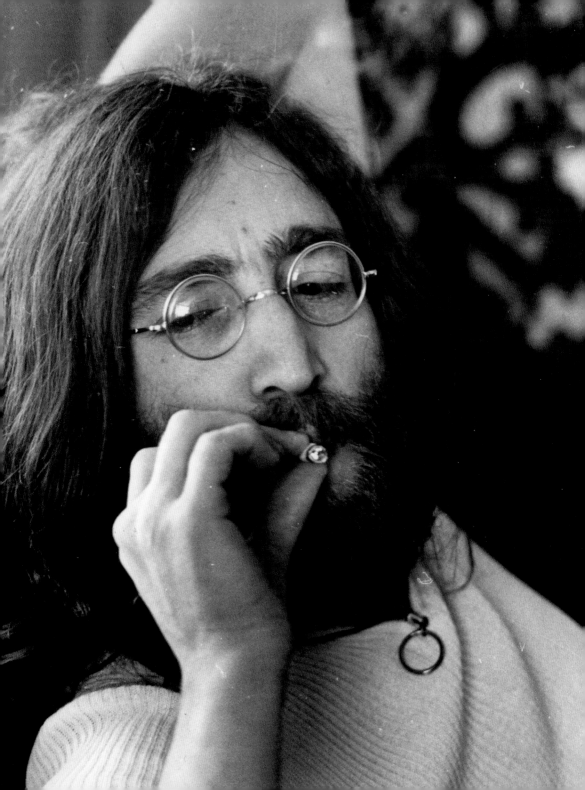

Well, he knows. He knows damn well. We're all naked, man. And I don't mind.

DEREK TAYLOR: What's this, John?

JOHN: Oh, it's just some butcher [laughs]. And he had a pinup on the wall, you know, and he was saying to the guy here, "It's disgusting, that *Two Virgins* album." I don't know what to do about those people. We know where they're at. And just leave them alone. Give them their dirty pictures and we can get on with changing the world.

JERRY: I read in the paper in an advertisement for "Get Back" and "Don't Let Me Down" and you say you do "the nifty guitar bit."

JOHN: [laughs] Ah yeah, the fab guitar bit [laughs].

JERRY: Everyone seems to think that George is the nice guitarist, and stuff like that, I'm not too keen on George, I like him and all that but you and Paul sort of like send me. I had a feeling that you're sort of drifting away from people. You're still like sort of a symbol, Beatles, like God, but in school if you ask them who their favorite group is they'll say the Bee Gees and stuff like that.

JOHN: Yeah, well the Beatles, they've been around too long for a lot of kids, we're old, you know, but we'll be around for a long time anyway, you know, making good records. But you can't get enthusiasm, the day-to-day who's in, who's out. We lose that all the time. Like when we left Liverpool, before we left Liverpool, we were playing in one club, and we were very in. We left that club and went to another club and we lost a lot of fans there, Beatles, you know, and we left Liverpool and they complained 'cause we left Liverpool 'cause you can never be in with some crowds. They're always going to want

the latest, whether it's the Bee Gees or the Mop Tops. You know, they go for crap all the time. And you leave them with that. You can't wait for them people. You can't keep kowtowing to their tastes, and I think the Beatles will probably get less and less fans but they'll be a damn sight more intelligent [laughing] than the mass of fans we've had, probably. You know, we can't afford to wait for the fans. We couldn't afford to stay in the Cavern in Liverpool and kowtow to two hundred people. We had to get out and make five hundred people listen and in that way we lost maybe one hundred of the two hundred and got another fifty further up the road. And you just gotta go on like that, swapping your audience. But you judge us on our music, not what the guy in class is saying.

JERRY: I'll talk to some kids in school, most of them like the Bee Gees and stuff like that. . . .

JOHN: The Bee Gees are okay, you know. They make some good music. But they're a different bag from us. There's plenty of other groups than us and the Bee Gees.

JERRY: What they'll say, the reason for it . . . I'll ask them why they don't like the Beatles—they're fantastic, they're great. They'll say because, for example, there are the marijuana charges and "They're all hippies and they're gone from us, they're dirty now."

JOHN: Oh, yeah, I see. Well those kids, they sound like son-of-square and [laughs] your job is to hip 'em up either to the Beatles or anything else. They've just got to get from underneath their parents' wings.

JERRY: I know. They're like robots. It's a pity . . .

JOHN: Yeah, right. You've got to show them what a good time you're having.

JERRY: Oh yeah, I have a really good time. My brother-in-law has a fantastic stereo set, and that was the first time I enjoyed you artistically, and I listened to *Sgt. Pepper* on it and I nearly blew my top. I had the music on full blast with the earphones.

JOHN: That's how we make it. Full blast. The only way to listen to Beatles music is full blast.

JERRY: Right! That's what I was saying. Now I listen to your double LP [the *White Album*] and *Two Virgins* and I go crazy, really. This week I have a presentation in English . . .

YOKO: John, we should give him our new record.

JOHN: We just got John and Yoko's latest album with us. I'll give it to you now—it's called *Life With the Lions*. It'll really blow your mind. It's a live performance Yoko and I did in Cambridge in England to the students, and it was strange for me playing to two hundred people instead of thirty thousand [laughs] but I really dug it, and I'll give you the album now. You can play it around. It'll blow your mind.

JERRY: Fantastic. You know my stereo set is just a normal $100 one with just two speakers and it's not half as much, but when I listen to it I can at least dream of the experience I had listening to it on his stereo . . . the experience I had of it and that's the first time I've ever really taken a liking to something as much as that.

JOHN: That's great. If you're the only one in school that can dig *Two Virgins* or *Life With the Lions* that's enough for us. It's a start. We read . . . they asked some people in a pop paper . . .

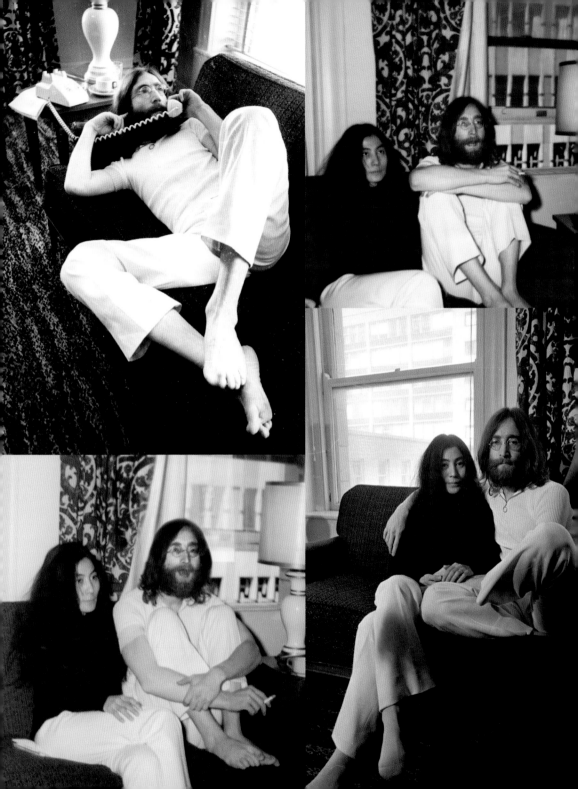

DEREK: I think one in a thousand is pretty good [laughter].

YOKO: *Life With the Lions*, we have to give him a copy.

JOHN: Go and get it then.

YOKO: Where is it?

JOHN: Ah hah! [Laughter.] In one of the twenty-nine bags. Some twelve-year-olds turning on to *Life With the Lions* in England. One of the pop papers asked the kids to criticize it 'cause most of the criticism of John and Yoko music is "What is it?" [Laughter.] It's amazing. Twelve-year-olds writing, "I play this every morning before I go to school, it blows me mind." Yoko is always saying, "They'll get it, they'll get it." And I say, "They're not going to get it, there's no off-beat." And she was right. You know, it's going to be pop music in five years what we're doing now.

JERRY: Everyone seems to think the best album of yours was *Sgt. Pepper*. I disagree. I think you better yourselves all the time. For example, the double LP, I was wondering . . . I never try to think of you . . . start studying with a microscope . . .

JOHN: Yeah.

JERRY: . . . your albums . . . till I find out . . . it just comes to me and once I just got this feeling out of your double LP after I was listening to it for a long time . . . and it just came to me . . . this is probably just a coincidence . . . but I started to get this feeling that there's a message in it. And the message was, on the first side seemed to delve into the lives of people. Like, for instance "Back in the USSR" which I think is life in the UK?

JOHN: It's anywhere, you know. It's anywhere. Messages are there on all levels in all music. And whatever level you get it on, I've had it too

when I wrote it or sang it. But some of that stuff, I write it, record it, and play it, and I don't hear it till a few months later and I'm lying down with a set of headphones and listening to a Beatles album and try to hear it in retrospect, objectively. And then I hear it and say, "Oh, was I saying that? Oh, I see, I see what it's about." And it's about everything. It's about UK, about USSR, and it's about nothing and it's about the USA. Anything you hear is there. It's all there, either trivial or profound, whatever, it's all there. And the same as in a flower, everything's there. It just is, and if you look long enough, everything . . . all answers [laughs] are in it and the same with the music.

JERRY: This is probably a dinky question to ask you but the Maharishi, I was wondering, do you think he was just a farce? I want it right from the mouth.

JOHN: He wasn't a farce. I still meditate now and then. I just found that I couldn't do it every day. It's like exercising, you know. I couldn't get up and touch me toes every day. But the meditation was good and the three months in India produced all them songs on the album [the *White Album*], not the fact that I was just in India, the fact of what I was doing, the meditation, and how I felt. So they all thought he conned us out of money. He never got a penny out of us. All he got was publicity. And he was for peace, so we gave him publicity, that's okay. He's a good guy, you know. And if he did con other people out of money I don't know. Somebody will find out and so what. Money's only paper so let him have it. But he gave me a lot. He gave me an experience and he tripped me out in India and I don't regret it one bit. I'm here now, and that's the end of it really.

JERRY: Was it George . . . the only thing I can get to know what's happening really is to read what I can get out of the papers and one of these magazines with pictures . . . and all I can get is that George is sort of the only one who's thinking of breaking out of the Beatles . . . he's the one who's sort of dwelling into his own little laurels, writing his own kind of music, like *Wonderwall Music* . . .

JOHN: What do you think I'm doing with Yoko?

JERRY: I never thought of that [laughter].

JOHN: What would you think I'm doing? They're always blaming me for that. Ringo Starr is making these films all the time. I'm writing songs, you know. We're all doing, I mean, I was writing them books years ago. We're all doing our own gig as well as Beatles. You know, one is the Beatles and the other is four individuals.

DEREK: The Beatles are five entities, the Beatles and its four members.

JOHN: Yeah. One is the Beatles and the other is four individuals.

JERRY: I read your book *The Penguin* [*In His Own Write*]; I borrowed it out of our library. Our school is pretty hip, they have a whole bunch of Beatle books. And there's one poem of yours . . . "Poor Nigel."

JOHN: Arf! Arf!

JERRY: It keeps on driving me buggy and I'll keep on remembering it.

JOHN: That's great [laughter]. It drove me buggy too till I wrote it down.

JERRY: I wanted to finish this . . . about your double LP, the first side was mainly about people. And the second side I sort of get the feeling it's about love—"Martha My Dear," about Paul's dog, and "Julia" about your mother.

JOHN: Yeah.

JERRY: And the third side sort of got into the feelings of sensation. "Birthday" gave me a really crazy kind of feeling.

JOHN: Yeah.

JERRY: And the fourth side, it was all about life. "Revolution" then "Revolution 9," which I could go on about for ten years, that's the most greatest thing you ever did . . .

JOHN: Good.

JERRY: Number nine, number nine. Anyway, you put all these together and you get People, Love, Sensation of Life.

JOHN: Well, you just get what four guys are going through at that time, where the Beatles are at or what they are feeling at that time. And that's four guys' experience all trying to get it on one hour's plastic, you know, you got it all out of it. And we didn't constantly say, "Now this side is going to be about that and this side is going to be that." We set it out like a show and juggled with it for about twenty-four hours and listened to all them tracks over and over saying, "No, that one kills that one if you have them next to that one." And we're laying it out like that. And it turned out like you said. It's just four guys' experience and we're singing about it. We reflect where we're at at the time and how we're feeling the moment we're making the record.

JERRY: In "Revolution 9," it seems to be about what you're bringing a child into.

JOHN: Yeah.

JERRY: But at the beginning, and this I could only pick up with a good stereo, and it had something near the end, "Yes, you fucking bitch, you should have thought about that before you fucked Laura, George." I was trying to think of what was going on here.

JOHN: I don't remember saying that. I have no idea what we were saying on it. We just rambled on. There were many loops and tapes and I was cutting up Beethoven and playing him backwards, anything I could lay me hands on. It's a montage, and George, Yoko, and I just talked all through it. But the very end piece is where Yoko comes in on a cassette saying, "And there you stand naked" What about that bit? The very end, the voice of me changes? But I don't remember *fucking* or *assholes* or anything like that. Although it might have been there, I don't know.

JERRY: Near the end of "Revolution 9" you hear a whole bunch of crowd sounds—"daa, daa, daa." I can't understand what that is.

JOHN: I don't know what they're saying, either. I just got them from the sound effects thing. And they're going sort of "ooh" and "aah."

DEREK: Where's the key to the big box?

JOHN: Oh, the key to the big box? I don't know. I've no idea where it is.

DEREK: In your white jacket, maybe, from last night.

JOHN: Oh okay, I just shoved that in the black hand case there. My hand luggage there. Last night's white jacket's there.

JERRY: When you decided to give the film of you singing "Get Back" to the *Glen Campbell Show* . . .

JOHN: Did we?

JERRY: Yeah. Oh I'm glad, I thought you really thought about let's pick some nice American and so picked Glen Campbell.

DEREK: That's like the *Smothers Brothers* or the *Tonight Show*.

JOHN: What about it?

JERRY: Everyone knows I'm a Beatle fanatic and when it was on TV a friend called and said, "The Beatles are on *Glen Campbell*," so I switched it on and they had his Ma and his Pa from Tennessee or wherever. And then all of a sudden at the very end I saw you guys. It seemed sort of freaky. Really gone. Don't you guys know where your films go to?

JOHN: We just tell them to get them on the biggest networks, or somebody like the *Smothers Brothers* 'cause we heard they were having a hard time. Otherwise we just put it on the maximum . . . the show that's going to be seen by the most people. Unless we particularly know and dislike the guy. I just heard Glen Campbell and he's on and everybody watches it so stick it on. It's like that. People will see it then. The Beatle people, like you, get informed that it's on. Whatever it's on. Even if it's on the news. Unless there's some specific show that we know about that we want it on we just tell them to put it on somewhere where it will get maximum exposure.

JERRY: I was just reading a book about Ed Sullivan and there was a picture . . .

YOKO: Here it is [the *Life With the Lions* album]. We'll sign it for you.

JOHN: Oh yeah, what's your name?

JERRY: Jerry.

JOHN: Go ahead, carry on talking.

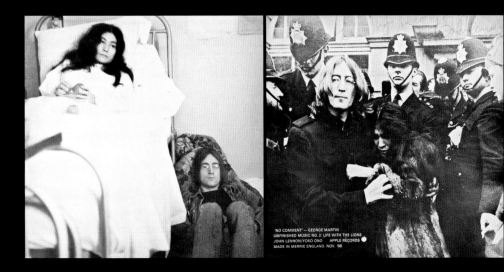

'NO COMMENT' -- GEORGE MARTIN
UNFINISHED MUSIC NO. 2: LIFE WITH THE LIONS
JOHN LENNON/YOKO ONO APPLE RECORDS
MADE IN MERRIE ENGLAND. NOV. '68

JERRY: And he had his hands up and said, "Let's hear it . . . the Beatles." And I was wondering, did you like Ed Sullivan? Is he a good friend of yours?

JOHN: He's no friend. I mean a friend in as much as he's a contact. I can't describe the word for what the people are who you meet. He's not a friend or an enemy. He was just somebody who put us on his show and we were happy to be on it. When we heard about it we thought, "Great, great." You know. "We're on that show and that's where Elvis was, and we're going to be on it," and we were terrified and all that bit, and Ed Sullivan is Ed Sullivan. There's always going to be Ed Sullivans on TV. And the thing is I used to loathe him as a kid or younger. But now it's just a howl. We've got him in England. They're always there. You just mustn't let him get under your skin.

JERRY: He's turned really hip. Probably some spiritualistic change has come over him.

JOHN: Oh, has he?

JERRY: Yeah, he has sideburns now and he actually does more than just talk. He'll dance or something like that.

JOHN: Amazing. Maybe he's had some acid. 'Cause he used to just stand there and say, "And . . . here . . . come . . . the Beatles . . . from . . . Miami Beach. . . ." He was okay, he was never nasty or anything. A lot of them, when you haven't quite made it, treat you like scrum, and he was always kind and tried to make us feel easy. So that means he's okay as far as I'm concerned. He's not my cup of tea as far as entertainment is concerned but he was kind to us, you know, and so we respect that. Especially before you've made it.

JERRY: Who's your all-time favorite singer or composer?

JOHN: I haven't got one . . . I've got many. Yoko [laughter].

JERRY: How about yourself?

JOHN: Yeah, me first then Yoko. Okay.

JERRY: Just to finish this off, my number one on my list is the Beatles, number two is Pierre Trudeau, and number three is Jerry Lewis.

JOHN: Jerry Lee Lewis or the comedian?

JERRY: No! Jerry Lewis the cool guy.

JOHN: Oh. Who's Pierre Trudeau? The prime minister?

JERRY: The prime minister. His full name is Joseph Philippe Pierre Yves Elliott Trudeau.

JOHN: I loved Jerry Lewis like mad when I was younger and going to the pictures in Liverpool. I used to see every film and howl about the floor pissing and crying with laughter.

JERRY: That's fantastic. He's my number three guy. Anyway, thank you very much, John . . .

JOHN: It's a pleasure, man.

JERRY: . . . and thanks, Yoko.

JOHN: Bye-bye. Here's your album.

YOKO: Good luck. And peace.

JOHN: Play that album. And, oh yeah, peace.

THE END OF THE INTERVIEW came about not because Derek or John stopped us, but because I realized I was taking too much of John's time. He probably would have let me go on for much longer, even though no one else got to interview John and Yoko that day as they immediately left for Montreal.

The interview was supposed to be about peace and that was his and Yoko's final words. Considerate and mature enough not to criticize the American people or its government, John did not even mention Vietnam. John and Yoko's campaign was directed at all countries and particularly the culture that promoted war. The messenger of love and peace wanted to conciliate and persuade, not to alienate or pontificate. He wanted a dialogue with fans, opinion makers, and the establishment. For the first time in pop history, a star took on the political responsibility of giving leadership to his generation. This would not simply be a foray into politics and social commentary. Unlike his "bigger than Jesus" statement, his comments were thoughtful, pointed, and deliberate but aimed at dialogue and persuasion. That John embraced my idea—have a kid conduct an interview aimed at kids—underscored the sincerity of his objective.

And when I asked him what we could do to help him, he did not lecture me. Rather he talked about personal responsibility and being cautious: Help me by helping yourselves. If you run around violent, you get smashed. These were the comments of a thoughtful and considerate man who understood the gravity of the times and the power he wielded, and had a vision for a better future.

Early on in the interview I noticed that the few other people in the room, Derek Taylor (who would bob in and out), a Capitol Records public relations man, and the CHUM disc jockey formed a circle around John, Yoko, and their young fan. They were listening in on probably his most unusual interview. Within minutes of the exchange, John invited Yoko to answer. She began, but quickly deferred. I have often looked back at that moment and understood it when it happened.

Though the peace campaign was inseparable from Yoko, she was quick to let the young fan have all the time with his idol. Those moments must have been very difficult for her and yet I remember her generosity of spirit. She sat by and watched and smiled as I had my life-altering encounter with her husband and partner.

After about some twenty-odd minutes, I realized that no one, let alone John, was stopping me, and I became acutely aware that I was monopolizing his time. I stopped the interview so abruptly that John said, "Don't forget your album," and handed it to me. It was *Life With the Lions*, the latest John and Yoko release, hot off the press, and his very own copy. "It'll blow your mind," he told me.

The deejay started putting his equipment away—unplugging the recorder, taking out the tape reel carefully, and putting it into a box. I found it incredible then and now that he had not uttered one word to John. John would have undoubtedly answered some questions, and he too would have had a scoop. Yet he must have been either so taken with what he had just observed or simply could not summon up the courage to speak.

Rather than ask me to leave, John and Yoko continued chatting with me. I told them again how much I liked their music. I asked him about the album cover and what the photos were. Yoko told me that the black-and-white photo—John valiantly clutching a distraught Yoko surrounded by London bobbies—was when the police charged them for drug possession. "It was terrible," she said, shaking her head. Turning the cover over, I asked what the colored side was. Yoko was silent, and John told me it was when she'd been in the hospital. That is all he said. I came to know later that it was when Yoko

suffered a miscarriage and John slept on the floor next to her. The album itself included three songs about that experience: "No Bed For Beatle John," which had John and Yoko singing out newspaper clippings about them; "Baby's Heartbeat," an actual recording of their child before the mishap; and then "Two Minutes Silence," which was just that.

At that moment, Derek Taylor popped in again. "John, Mary Hopkin has flown in and is opening for Engelbert Humperdinck tonight here in Toronto. She sends her love." "Send it back," John said, looking at Yoko and then chuckling to me. Mary Hopkin was the seventeen-year-old protégé of Paul. He had seen her on a British talent show called *Opportunity Knocks* in 1967, and for her, opportunity knocked big time when he invited her to an audition in London. Taken with her voice and innocence, McCartney produced "Those Were the Days," which became a massive worldwide hit. Sweet and lovely, pretty and poppy, it was precisely not what John was into at the time and his reaction made clear to me, months before we would learn of the real rancor and artistic disputes within the Beatles, the tension that existed between John and Paul.

"You want to go in me place?" John asked me with a twinkle in his eye. "Sure thing!" I replied, amazed that I was still being treated to such gifts by my hero. He motioned the Capitol Records PR man forward. "The lad here will go in me place to the Engeldick concert to see Mary Hopkin. Make sure he gets a good seat and give him the VIP treatment." The PR man nodded deferentially and stood waiting for other commands. I stood up and then so did John and Yoko.

"Thank you so much, John. I'll never forget it," I said staring into his kind eyes. "Thank you, Yoko." "Pleasure, man," John said smiling, picking up the album because I had forgotten it again.

Yoko left the room, and John put "The Ballad of John and Yoko" on the turntable again and playfully danced with Kyoko. The PR man gave me his card and on the back wrote a note for me to give to someone at the theater. "I'll see you there later. This will get you in to the show and to the party afterwards." He barely finished his sentence when a jolting thought went off in my brain. "John!" I shouted, somewhat startling him. "How do I get in touch with you?" He smiled and took a calling card from the PR man. On its back he wrote:

Anthony Fawcett
c/o J & Y c/o Apple
3 Savile Row
London W1S

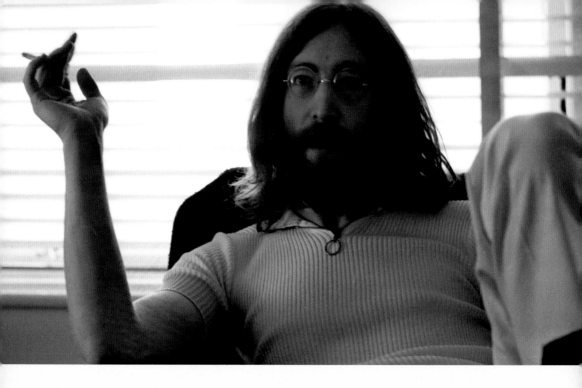

"Whatever you write will get to me." "Thanks, John," I said. "I won't
let anyone else know." "That's the lad," he replied, nodding his head
with an approving smile.

 The deejay asked if I was all set, and I said yes. I did not want to
go, but I knew that I had to. I waved good-bye to Derek Taylor who
reciprocated as he walked towards me to escort me out. John looked
at him and motioned with his head, as he put his hand on my shoulder
and walked me to the door himself. He opened it and faced the long
row of silent reporters who gazed at this incredible sight.

 "Thanks again, John. I'll write to you!" I announced as the row of
salivating correspondents turned their heads towards me in unison.
I flashed a peace sign backwards and John corrected me by doing it
the right way, and closed the door. Everyone stared at me.

 John and Yoko did not stay to meet with any of them. They left
abruptly to catch a plane to Montreal. The following story appeared

in Toronto's *Globe and Mail* describing what took place shortly after John closed the door and said good-bye to me:

FANS AMBUSH BEATLE, OUTWARD BOUND

John Lennon sat back in the taxi and gave a sigh of relief late last night, on his way to Malton to catch his flight to Montreal. Moments before he had been engulfed by Toronto teenagers who had pushed past police and descended on him.

He had hoped to make a secret exit from his Toronto hotel. He had left phones ringing, carnations littered over beds and rugs, unopened letters, fans screaming from behind burly policemen along the hotel corridors.

Down some sort of fire escape we had fled, any moment expecting to be deluged by fans. It didn't happen until we were almost out of the building.

Rushing out of an elevator, they were suddenly on us. Somehow the police regained control, we were shoved into the cab, the garage door opened and we drove out. Fans climbed onto the car but they jumped or fell off as the cab gathered speed. Lennon looked tired. Yoko didn't seem to care. Lennon, all in white, sighed again and said: "I think Ringo [Starr] was right about not touring."

Ritchie Yorke/the *Globe and Mail*

In fact, given the timing of their return from customs and their quick exit from the King Edward, I realized later that John and Yoko might very well have stood up the entire Canadian and American media to sit down and talk with me.

I walked down that hotel hall and turned the corner towards the elevator. The deejay, whom I have since tried to track down unsuccessfully, walked with me. He still had nothing to say. The cordoned-off crowd of kids had ballooned to five or six times the size it had been just a couple of hours earlier. They were screaming, being held back by tired and bewildered police. "Did you see him?" "What was he like?" "Oh my God!" They were shouting at me and gasping. There was desperation in their eyes. "He is the greatest," was all I could say. I meant it and got into the elevator.

"When can I have my tape?" I asked the deejay, and he said probably the next day. "We'll play it on the news tonight and tomorrow." "Thanks," I said and I made my way through the mini-riot that was happening in front of the hotel. The crush was enormous. Kids, photographers, crazies, and the curious, waiting to catch a glimpse of the greatest star on earth. My salvation was that I was walking the other way. I was going to see a show thanks to my benefactor. Luckily, the theater was just a few blocks away, and I was eager to sit down, put my mind on hold. Take it all in.

I cannot remember whether I called my parents or not. I probably did, but either way, I was not in the mood to brag or shout about what had just happened. I knew that this was transformative and that it required reflection. It was not really a choice. Nothing in my life before or since had fit so perfectly. Every moment—from the

time I heard about the rumor to walking to the O'Keefe Centre—had fallen into place with fatalistic precision. And it was not over yet.

Engelbert Humperdinck was a star then. Hailing from Leicester, England, he was the smoother version of Tom Jones. Not my kind of star or popular with the kids. He was a crooner with outlandishly parted black hair, sprayed wavy curls, and sideburns the shape of Italy. In fact the irony of the gift John gave me, which no doubt did not escape him, was that Engelbert's "Release Me (And Let Me Love Again)" was so huge that it kept "Penny Lane" and "Strawberry Fields" from reaching number one in the UK charts. That was unprecedented.

There I was amidst couples and groups of women crowding into the O'Keefe Centre to see Engelbert. The O'Keefe was the place big celebrities and shows would come to in Toronto. Richard Burton, who played King Arthur in *Camelot*, Harry Belafonte, Louis Armstrong, Duke Ellington, and Count Basie all played there. I doubt anyone bought tickets just to see Mary Hopkin. The last time I had been there it was to see Danny Kaye with my family a few years back. My Dad took us to the side of the building to catch a glimpse of him. When he came out the stage door to a gaggle of mostly elderly fans, he did not stop and his bodyguard pushed them, including my father, away. I was having a radically different celebrity experience that day. At the front door I showed the Capitol Records card, and the usher called someone on his walkie-talkie. Within minutes a matronly woman arrived and I was whisked through the line and seated in the center seat, front row. No one will ever believe anything I say about this day, I thought.

I flipped the pages of the program and focused on Mary Hopkin. She was part of the Beatle family even if John preferred Yoko's music.

The lights dimmed and the familiar intro to "Those Were the Days" began and out walked the pale, blonder-than-blonde Mary Hopkin. She sang that song to rousing applause. Sitting there on top of the world, I really believed the life ahead of me would be glorious. "My next song," she softly said into the huge microphone "was written by my friend Paul McCartney and is my new single." The audience burst into applause, oohs, and aahs. For the second time that day I was hearing an Apple release in the presence of the artist. Mary Hopkin was no Beatle, but Paul's unmistakable upbeat melody was there when she sang "Goodbye." There was a short break between the acts, but I stayed glued to my seat. What would Engelbert be like, I thought. He was scary-looking on TV. I wondered if he was scarier in real life.

"Ladies and gentlemen," an announcer boomed to the sound of timpani drums. "Mr. Engelbert Humperdinck!" I laughed out loud when he and his tuxedo oozed onto the stage carried by a sweltering orchestra. Women responded to his debonair style with shouts and threw their panties at him. "Release Me." "There Goes My Everything." "A Man Without Love." "The Last Waltz." I knew all of those songs—they got serious radio play. Impatiently I sat there, bouncing my legs as I did when I was nervous, wanting the time to pass by quickly so that I could go to the after-party.

At the end of his set, Engelbert faded into the curtain to the sound of adoring women. I got up and dashed to the PR man waiting in the wings. "Having a good time?" he asked, rubbing his hands and broadly smiling at me. He was balding in a George Costanza–like way, smelled of cologne, and wore a shiny gray suit. "Sure am!" I replied.

"Well let's have some more fun. We're going to the party and you can be my photographer." He took my arm and led me through the exiting stream of post-orgasmic women to a party room where there were hors d'oeuvres, canapés, champagne, oysters, shrimp. I had seen things like this on TV and in movies, but had never been exposed to it. Chopped liver on a Ritz was as fancy as it got.

People were lounging about the bar and at the center food table when a mad cluster of people blobbed through a door. Flashbulb bursts and applause greeted the great Engelbert as he entered the room. Autographing, hugging, and posing, he flowed through the room with that same cluster. The Capitol man asked me to take pictures of Mr. Humperdinck with a few people. Sam the Record Man was one of them. "Hmmm," I thought. My picture would probably end up in the store somewhere in the endless row of celebrities.

After a while it started to get boring and late. I was thirsty and walked around to see if there was water somewhere. The bar was packed and I did not feel like fighting the crowd. I went to the other end of the room and saw Mary Hopkin sitting alone at a round table sipping ginger ale through a straw. The commotion was for the headliner, not for her.

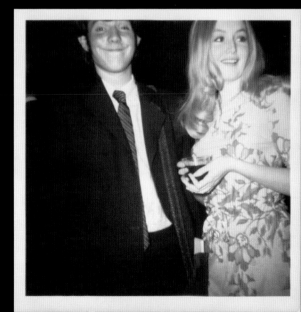

"Hi," I said, as a fourteen-year-old would. "Hi," she answered. "Have a seat." "Sure thing," I said, and with that plopped my tired body down beside her. "Great show," I told her. "Especially your part. I'm not a big fan of you know who." She smiled, thanked me, and shrugged her shoulders. I had never seen anyone like her. She was a natural blonde with a full body in a tight minidress. Her skin was translucent and she smiled in a naturally shy way that covered some uneven teeth. Her accent was Welsh and there was a real gentleness about her.

"What brings you here?" she enquired and I was glad to fill her in. "I just came from meeting John and Yoko. They're here you know. Here in Toronto." "That is so exciting," she said and seemed rather happy for me until I took out the *Two Virgins* album. She had a pained look on her face and erupted into a nervous giggle. "He signed it over here, and Yoko did too. And look they gave me this new one. *Life With the Lions* they call it. That's Yoko in the hospital." Mary was the first person I could tell the story to and I gushed with details. She was polite and listened attentively.

The Capitol man came by with some industry people and Sam, and asked for some more photos. He motioned Mary to stand up and she obligingly posed with the group. I took out the Brownie camera once more and snapped away acting like a big shot in front of my new friend, "Would you like one too?" she asked, and I jumped at the chance. Someone took the camera and snapped. At the same time someone else called her name and she looked away. But I looked straight into the camera beaming and proud of that moment and the last sixteen hours of accomplishment.

Engelbert had left the room and it began to die down. It was 11:00 P.M. and I was ready to go. "Here is my card," the Capitol man said. "When the photos are ready, give me a call. I'll give you some records." I threw my bag over my shoulder and told him I would call him right away. As I was about to say good-bye to Mary she burst out, "I'm being treated to a night out tomorrow at a posh nightclub. Would you like to come with me?" "For sure! Yeah, for sure!" She smiled shyly again and said, "Wonderful. It's a place called the Electric Circus. Be there at 8:00." "Electric Circus. Eight o'clock. I'll be there. Thanks, Mary." I waved, I smiled, I waved again, tripping on my own feet as I walked backwards. I made her giggle as I played up my clumsiness, bumping into tables and chairs.

I left the room and walked onto the plush carpet of the theater. Cleaning ladies were vacuuming and the place was empty. It was dark outside and I was alone on the streets of downtown Toronto on a warm spring night. Union Station was a ten-minute walk and luckily, I'd remembered to bring bus tickets. There were not too many people on the bus when I sat down in my favorite solitary window seat. It was, after all, late Monday night. There was work and school tomorrow for my fellow Torontonians. What was in store for me? I wondered. Would anyone believe me? I had no pictures or the tape yet, just autographed albums. Anyone could have signed them. I could have signed them. I began arguing with detractors in my mind.

The time went by quickly. I had replayed every moment. I remembered the way John smelled. The ashtray. How Yoko looked. "The Ballad of John and Yoko." I embraced the albums. The caricature

of John and Yoko was amazing. "I have a cartoon of John and Yoko, drawn by John!" Wondrous. Unbelievable. It was a day that was planned in heaven. I believed in God. I believed in the Beatles. And I believed in the greatest hero of them all, John Lennon. It was quite a few blocks to my home from the bus stop. Was it midnight yet? I did not bring a watch. Turning the corner onto Searle Avenue I could see that all the suburban bungalows were dark. Except one. My mother and father came running out when they saw me, my mother crying with worry. "I'm okay. I'm okay," I repeated to them. "I was with John Lennon. I really was. This has been the best day of my life!"

I had no idea what to expect when I played John and Yoko's gift to me. The album started with a live performance by Yoko. "This is a piece called 'Cambridge 1969,'" she says softly in front of an attentive crowd before they witness her remarkable vocal display and accompanying feedback from John's guitar. That went on for twenty-six and a half minutes. Listening to that album over and over again, the record player on repeat, it was as though I had taken a crash course in the abstract, the bizarre, and the experimental. John and Yoko's gift to me played all night long and was still playing when I woke up, reminding me that this was not a fantasy. It was real.

The next morning I told my brother everything that had happened. He alternated between laughing and staring. Was I telling the truth? I was always given to hyperbole, even outright fantasy. He inspected the albums with the eye of a physician. "The cameras!" I shouted out. "Is there film in the cameras?" Steve checked out the Kodak Brownie. "There's film in here," he said as he rewound it and took the cartridge out. Then he looked at his Super 8. "Film here."

This was all too good to be true. There was a chance I would have pictures and a film of John and Yoko! In those days it could take a couple of weeks to get still pictures developed and longer for film. "The tape! The tape!" And then I remembered, "CHUM has the tape and they will use it on the news!"

We tuned onto 1050 on the AM dial and waited for the news. It was almost 8:00 A.M. Then news came on with this announcement right off the top:

JOHN LENNON

IN AN EXCLUSIVE WITH CHUM HAD THIS TO SAY ABOUT WHAT YOUNG PEOPLE SHOULD DO FOR PEACE:

"There are many ways of promoting peace. Do everything for peace. Piss for peace or smile for peace or go to school for peace or don't go to school for peace. Whatever you do, just do it for peace."

Steve laughed, and I was outraged. "It's not you," he said. "It is me! I swear it is! They cut my voice out!" I was fuming when Steve drove me to the Kodak lab to have the film developed. I couldn't pay the rush price and had to make do with waiting a few weeks. We then went to school. Every fifteen minutes, CHUM played excerpts of my interview, all the time cutting out my voice and not giving me credit. Part of me started wondering if it really happened. It was all so crazy. "Wait! If you see Mary Hopkin tonight will you believe me?" It dawned on me that I had a date with her and that if Steve drove me downtown, he would see that she recognized me.

I walked onto the schoolyard greeted by a crowd of kids. Word had spread that I was seen at the King Edward in the evening and had gone past the police blockade. I had the two albums—one, *Life With the Lions*, no one had seen before. But that's all I had and no clear proof. "Again with the album," one nasty boy shouted. "He is full of shit."

After school I called CHUM and spoke to someone at the news desk. He hung up on me before I could finish my sentence. I called back. He hung up again. Finally he let me finish what I had to say. "Oh, you're the kid! No problem, call back tomorrow and we'll see what we can do." The fact that I had to wait to get my tape disheartened me. My mother was just coming home from work when Steve and I were heading off. I could see the look of worry in her eyes. "Where are you going now?" she asked. "I told you, Ma, I have a date with Mary Hopkin. Steve is taking me." Steve shrugged and off we went to pick up our cousin Larry who wanted to witness the event too.

Larry got in the car, and I told the story all over again for his benefit. The more I told it, the more I wondered if it really happened.

They wanted to believe me but it was too incredible a story to accept wholeheartedly. We stood outside the Electric Circus for about an hour before the designated time eating the hamburgers and French fries we bought on the way. In between slurps of milk shakes, they grilled me about details of my story to see if it held up. Eight o'clock arrived and there was a line up to get in, but no sign of Mary Hopkin. Eight fifteen and Steve started to get restless. By 8:30 I felt gloomy when Steve said, "Let's go." Just then a black limousine pulled up. The driver came around to the rear passenger side and opened the door. Out stepped Mary Hopkin with a beaming smile. "Hi, Jerry!" "Hi, Mary," I replied, to Steve and Larry's shock. She took my arm, and we were let right into the club. I turned and waved at my brother and cousin as I entered a nightclub, with a pop star, for the first time in my life.

Within twenty-four hours of treating me to an extraordinary day filled with life-altering experiences, John Lennon was unwittingly responsible for setting me up on a date with an Apple recording artist. Mary led me onto the dance floor of the Electric Circus. It was the hippest and newest club in Toronto and had state-of-the-art strobe lights. The place was packed and no one seemed to know that Mary Hopkin was there. I remember feeling goofy dancing to some number, all the while astounded that before me was this beautiful star from across the Atlantic, smiling and swaying to the music. All I could think was, "She knows Paul McCartney."

We were probably dancing to one of the hits of the time, "Hair" by the Cowsills or the theme from *Hawaii Five-O*, when the music shifted abruptly to "Goodbye." The deejay announced that "Apple recording artist Mary Hopkin" was in the room and a spotlight hit us

to the applause of everyone there. There I was dancing, sort of, with a pop star.

At some point the evening wound down, and Mary was being led out by the Capitol PR man, back to the limousine. I followed her and witnessed the crush of people who wanted to say hi and touch her. She had to get in the limo fast because of the crowd outside the club but she stopped to say good-bye to me. "Thank you for coming," she said sweetly and being the real man that I was I kissed her on the cheek. "Good-bye, Mary," I waved as she sat in the limo and the door closed. The window lowered and she waved back to me and to the fans. "Say hi to Paul," I shouted as she took off. Then I strutted away fully aware that people were staring at me wondering who the hell I was.

I called CHUM everyday and was told they would call me. But they didn't. I got into such a fit that one day I showed up at CHUM's head office and started yelling in the reception area until someone from the news desk came out to talk to me. I was turning purple and causing a scene. "It's my tape! It's my tape!" I kept shouting. "I'll be right back," he said nervously in front of the other people in the room. About ten minutes later he came back with a box that contained my taped interview. "Here you are." I took it and ran. When I got home I called my Uncle Mike. He had a reel-to-reel tape recorder and promised to come over in the evening.

We were still having dinner that night when Mike waltzed right into the house and into the kitchen. My mother, my father, Steve, and I sat there at the table watching him set up the tape that I'd given him. He pressed the play button. It was my voice asking a question,

a question that was answered by John Lennon. For some twenty-five minutes we sat there. My parents were mystified. Mike kept clapping his hands with enthusiasm. My brother gave me a look of awe. It was the first time I'd impressed him. "Wow, Jerry," he said softly. "You really did it. You really did it."

In the days following my meeting with John and Yoko, they spent a week in bed in a Montreal hotel suite. The door was wide open and anyone could get in. That was where he wrote and recorded "Give Peace a Chance," with Timothy Leary and Tommy Smothers chanting in the great chorus. I watched the news bits— there was no CNN back then—listened to the radio, and read the newspaper accounts of what my hero was up to. I felt part of what was happening even though I was far away. I would have loved to have been there but I would not have traded my experience for that one. I had been in the eye of the storm with John.

The moment it was ready, Steve drove me to the Kodak lab to pick up the film. I bolted out of the car and into the service department, gave the lady behind the counter my two slips, and watched her go through the drawer. The first was the Super 8 reel. My brother opened it up, raised it to the window, and pulled the film in front of his eye. "There's film here. I see John! I see Yoko!" he said. My God, I thought, I had proof, for the world and for me. Waiting for the photographs, I knew that if the envelope was thin, there was hardly anything there. "Here you go, that will be $15.95 please," she said, handing me the envelope. It was not thin. I paid the money and we went into the car. I sat down, closed the door, and took a deep breath. The film that was in the camera was for slides,

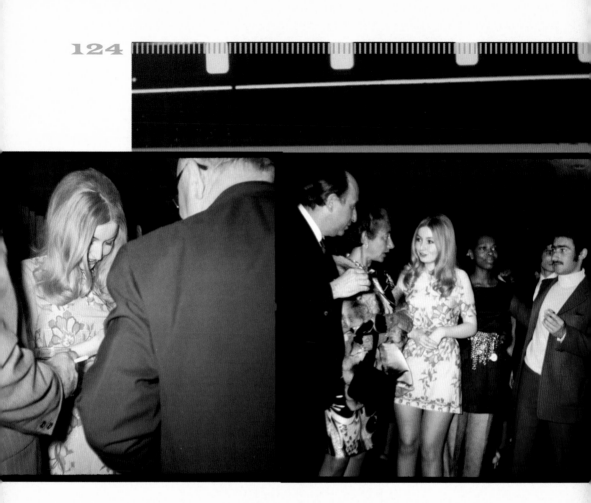

and there were many of them. I lifted them to the light and took off
my glasses. One by one I saw pictures of John and Yoko. They were
in focus. They were good. Mary Hopkin was there—a picure of
her with Sam the Record Man, another with me. Even Engelbert in
vibrant living color. "Let's trade," I said and gave Steve the slides.
Acting like a projector, I viewed the small frames of the film. Sure
enough, John and Yoko. I was there. I have proof. It really happened.

My father was so proud of me. He would introduce me to random people and say in his thick Yiddish accent, "He met the Beatle. My son is not a hippie, but he met the Beatle."

I kept my word to John and played my tape to a school assembly. A few teachers and the vice principal listened to it first with me in the office to make sure it was appropriate. A woman teacher was flabbergasted and kept saying, "Amazing! Amazing!" The vice principal was circumspect and was not happy about the "piss for peace" or "you can go to school or not go to school. . . . as long as you do it for peace." He cringed when I asked John if he said *fuck* on "Revolution 9." "We will have to cut some of this out," he said to the uproar of the teachers. "You can't do that," was the response. "It's John Lennon." He acquiesced.

The next morning, a large tape recorder was placed on the edge of the stage in the auditorium. Next to it was a turntable that I had set up. I sat there dangling my feet as kids entered. I was dressed all in white and wearing sandals. My round glasses were on. I was proud to wear them. And I could see clearly, the believers and the nonbelievers, let out from class to hear the world's biggest star talk to me and to them. When everyone was seated, teachers closed the doors and stood against the wall. My English teacher took to the stage and walked over to the microphone stand behind me. "You all heard the news about Jerry meeting John Lennon. You're all in for a treat, let's hear it for Jerry!" The sustained applause and hooting delayed me from pressing the play button. I had done the impossible. I met the Walrus. John Lennon.

The kids laughed when John was funny. They were silent and listened to every word when he was talking about peace, about the Beatles, and about Yoko. Some shouted "All right!!" when he suggested they not go to school for peace. As soon as the interview was over, I took out *Life With the Lions* and gently placed the needle at the beginning of side one. "This is John and Yoko's latest album. They gave it to me." Teachers, administrators, and students alike were incredulous at what they heard. Yoko's dramatic wailing and John's experimental feedback pierced the assembly hall. I let it play for about five minutes or so. There were stunned and attentive looks and there was laughter. John and Yoko hit all the chords they wanted to. People reacted. "I'm sure you will want to talk to Jerry but let's save that for lunch time," the teacher said. I continued to sit on the stage and watched people leave in an orderly directed fashion. Before they left, many of them crowded around me to tell me how great it was and to get a look at my album.

The Capitol PR man had taken a liking to me. I called him a day or two after I got the pictures to give him copies of the ones he wanted. The ones with Sam the Record Man ended up on the store's wall of fame, the wall I peered at time and time again. I had made my mark. The PR man would call me up from time to time to tell me that new records of interest were coming out and give me advance copies while taking me out for dinner.

IN MY LIFE

Rumors were rampant in September 1969, the week prior to Toronto's Rock and Roll Revival at the Varsity Stadium, that John Lennon was coming. The concert was scheduled for September 13 and the lineup consisted of Little Richard, Jerry Lee Lewis, Chuck Berry, the Doors, and a newcomer named Alice Cooper, among others. I called the Capitol man and he told me that it might happen and he would call me as soon as he heard anything. Deejays relentlessly plugged the massive concert and each time fueled the rumors that John Lennon would make an appearance. The night before, I got the call. "John's coming with Eric Clapton," the Capitol man said. I shouted with excitement. "Meet me tomorrow morning at the press office at the arena and I'll get you a press pass."

The all-day festival started in the morning and was going to go on through the night. I found the Capitol man and he put a chain around my neck with a card that said "PRESS." It was hectic there because of the artists, but the John Lennon rumor was persistent and some were saying all four Beatles would be coming. I made my way to the front row where press and VIPs had designated seats. I was getting used to this.

I sat in the sun watching these legends of rock. Chuck Berry doing his crouching duck walk to "Hoochie Coochie Man," Jerry Lee Lewis jumping on the piano as he sang "Whole Lotta Shakin' Goin' On," and Little Richard screeching and strutting to "Lucille." These were the Beatles' heroes and the artists they covered in their early albums. I was having a rock history lesson. I saw Jim Morrison, about a year and a half before he died, sing "Touch Me" with the Doors. Alice Cooper infuriated everyone in the front row, including me, by throwing a full watermelon into the crowd, splashing us all with the insides.

Throughout the day, I would wander backstage and check out the stars wandering around outside in the secure area set up for them. A friend from school was working backstage as a roadie and we started chatting. Jim Morrison walked right by us. His skin was weirdly translucent. Jerry Lee Lewis walked by and I excitedly shouted to my friend, "That's Jerry Lee Lewis!" My friend thinking I was referring to the comic, replied, "That's not Jerry Lewis." Jerry Lee, "the Killer" as he liked to be called, turned abruptly around and walked right up to his face and said, "You better believe it, Buddy!" and then stomped away.

It was nighttime and Little Richard had stirred the crowd into a frenzy. The over-the-top icon of early rock and roll finished his set with "Lucille" and strutted his glittered way off the stage. It was getting late and there had been no word yet about John Lennon. I knew something was up when several frowning Toronto police officers stood on either side of the stage. Then an announcer came out and said in a disbelieving voice, "John Lennon and the Plastic Ono Baaaaaannnnnd!" And out came the musicians: Allan White on drums, Klaus Voormann on bass (the Beatles mate from the early days in Hamburg who designed the *Revolver* cover), Eric Clapton, and then John and Yoko to tumultuous applause. I was front row and center. He was thinner than when I'd last seen him and the beard was thicker. Dressed all in white, he seemed unusually awkward and nervous as he approached the microphone while tuning his guitar and said, "Good evening." The crowd wailed reverentially. "We're just going to do numbers that we know. We've never played together before." The crowd didn't care. The twenty thousand fans screamed with approval as John sang into the microphone, "It's a one for the money, two for the show, three to get ready now, go cat go, but don't you step on my blue suede shoes." I had never seen the Beatles live, but barely four months after meeting him, he had come back to Toronto and I was watching him sing and play the guitar.

John sang two more rock and roll classics, "Money" and "Dizzy Miss Lizzie," his "Yer Blues" from the Beatles' *White Album*, and then premiered "Cold Turkey," which would be released at the end of October 1969. For the second time I heard a John Lennon song for the first time, in his presence. He ended that set with "Give

Peace a Chance." "This is what we came here for," he said, and got the audience to join in. Yoko was at his side throughout holding a microphone and adding sounds not found in the original recordings or anywhere else.

When John finished his set, everyone left the stage except for him and Yoko. He positioned himself behind her and did odd things with his guitar to the amplifier. It was as if he was stabbing it. It was *Two Virgins/Life With the Lions* experimental music. As one of the few in the audience who had listened to those albums, I was familiar with what they were doing. Not everyone was happy. The first song, "Don't Worry Kyoko (Mummy's Only Looking for Her Hand In the Snow)" clocked in at four minutes and forty-eight seconds and was the longest song performed. She topped it with "John, John Let's Hope For Peace" that went on for twelve minutes and thirty-eight seconds. In those days, concerts had nursing stations for people getting sick and having bad reactions to drugs. Throughout the concert an announcer would warn people about "some bad shit that was going around." When Yoko did her thing, a guy next to me held his head in his hands and repeated, "Bummer, bummer." I was ready to strangle him. He was ruining my concentration. I motioned for a policeman who was standing guard. He took one look at him and took him away to larger and more repeated yelps of "bummer, bummer." I was relieved.

I had brought my brother's Super 8 camera with me again. Though it was night, I was so close to the stage that I managed to get shots of John that I spliced together with a rudimentary editing machine (film was cut and then you used glue) and created one of

the most unusual pop culture home movies of all time—John and Yoko interspersed with scenes of flowers from my mother's garden, a roman candle going off, and a kitchen light being zoomed in and out became my personal documentary of the experience.

At one point John laid his guitar against the amplifier to a sustained feedback and they left the stage. Most of the crowd did not know what to do. They were stunned and had witnessed rock and roll history. John and Yoko treated the audience to rock and roll classics, a Beatles tune, "Give Peace a Chance," and "Cold Turkey," and then turned their performance upside down.

Sensing they were not coming back, I bolted for the press area inside the stadium. I had my pass and walked right in. The Capitol man told me that John was going to give a brief press conference in the locker room and took me there. A crowd of reporters was waiting for the Beatle as I climbed on top of a locker so I could have a good view. John and Yoko came in. He looked terrible. There was a greenish hue to his skin, and he looked frightened. Years later he would say that he was sick to his stomach from nerves at performing without the Beatles. At one point in the middle of a reporter's question, he looked up at me. There was recognition on his face and he smiled. My heart skipped a beat as he whispered something to Yoko. He remembered me.

John left the Rock and Roll Revival exhilarated. He had performed his favorite songs, and some of his own songs, at a concert with his musical heroes. And he had done so without Paul, George, and Ringo. It gave him confidence to shake the burden the Beatles had become to him, and as Ringo later recalled in the *Beatles Anthology*,

within days of his return he announced to his brothers at a meeting at Apple, "Well, that's it lads, let's end it." The others convinced him not to go public, that they should wait for *Abbey Road*'s release, which was due September 26. The world had no idea when that classic album hit the radio waves, the store shelves, and the turntables that it was the Beatles' swan song.

I got the call from Capitol Records a couple days before. Steve drove me to their offices and the Capitol man came down to greet me. He smiled as he handed me *Abbey Road*. Like so many other Beatles-related moments, I remember how I felt when I saw it for the first time. Untitled, yet again, the Beatles, like superheroes on a mission, crossing Abbey Road where EMI's recording studios were. They were walking away. George in jeans, casual and independent. Paul in a dark blue suit, cigarette in his hand. Ringo, dressed to the nines and ready for the show. John, all in white, bearded and purposeful. The photo probably had been taken around the time we met. On the back, like a London street sign attached to brick, was written "Beatles." They had followed the minimalist approach from the *White Album*. They did not have to say who they were or jazz up the cover. They had been there and beyond with *Sgt. Pepper* and *Magical Mystery Tour*. They were the biggest rock band ever.

Just like the others before it, I listened to that album all day and all night, feeling a part of it all. John breathing "shoot me" started it all on "Come Together." Like the airplane on "Back in the USSR," the opening sound of the album was wildly original and set the tone with John at his lyrical best. "One and one and one is three. . . . Hair

down to his knee. . . . Hold you in his armchair you can feel his disease. . . . He shoot Coca-Cola. . . . Come together, right now, over me." Phrases to last an eternity. Paul playing bass wrapped around Ringo's rolling drumbeat. George harmonizing his lead and John grunging out the chords on his guitar. It was scary, it was funny, it was street theater. And it was pure John.

George's "Something" was beautiful. John thought it was the best song on the album. He wailed his sliding lead guitar throughout defying any duplication. What I loved most about it was how sweetly Paul accompanied George on bass and in the chorus harmonies. The master of ballads knew that his younger mate had written a love song to match anything he had ever created. Yet Paul clearly held nothing back. It was the music after all. Even at this time of terrible discord and alienation, they were mates who loved each other and supported each other to achieve artistic perfection.

Side one was John's idea. He did not want another thematic *Sgt. Pepper.* Just straight ahead rock and roll songs. "Oh! Darling," Paul's screaming tribute to Little Richard was so pure rock and roll that John always said he should have sung it. The Beatles rallied around Ringo and his "Octopus's Garden" to give the least likely songwriter of the group his moment of independent fame. To end it, John's haunting and primal love song to Yoko, "I Want You (She's So Heavy)." Soul, rock, jazz, and orchestral, the Beatles demonstrated how contemporary they were, always with a foot planted in the future.

"Here Comes the Sun" was a perfect uplifting opener for side two after the climactic ending of "I Want You." "Because," the Yoko-

inspired backward Beethoven harmonic masterpiece, followed, leading into Paul's vision, the *Abbey Road* medley: "You Never Give Me Your Money," Paul's fragmented lament for what the Beatles had become (a song he has to this day not performed publicly); "Mean Mr. Mustard"; "Polythene Pam"; and "She Came In Through the Bathroom Window." John and Paul were two super mutants battling each other with blasts of musical genius. They did this to "The End" where they dueled lead guitars with George right down to the finish. But the Beatles never took themselves too seriously. The last cut was Paul singing to Queen Elizabeth on the acoustic and raunchy "Her Majesty": ". . . someday I'm gonna make her mine, oh yeah, someday I'm gonna make her mine."

In October 1969 I heard an amazing thing on the radio. John Lennon had recorded a new song—one he had tried to unsuccessfully convince the Beatles to record—under a new name, the Plastic Ono Band. Within seconds of the deejay sharing that news, he played it for the first time. Unlike any Beatle song before, it began with a piercing, unmistakably Lennon lead guitar. It was "Cold Turkey," the song I heard John perform live at the Rock and Roll Revival. He openly talked about kicking heroin addiction. Was he using heroin when I met him, I wondered. He would later say that the stress of introducing Yoko to the Beatles contributed to his use of the drug. Classic, honest John, "Cold Turkey" had him singing and screaming about pain and hardship. It was the heaviest pop song ever. Shortly after its release he returned his MBE (Member of the British Empire) medal to Queen Elizabeth with this letter that he circulated to the press:

Your Majesty, I am returning this in protest against Britain's involvement in the Nigeria-Biafra thing, against our support of America in Vietnam, and against Cold Turkey slipping down the charts. With love. John Lennon of Bag.

In December 1969 John and Yoko came back to Toronto. They launched their War Is Over campaign in Canada and posted billboards in eleven cities around the world proclaiming that indeed war was over "if you want it." I was proud that they chose Canada to be the center of their campaign and was over the moon when he met my other hero prime minister Pierre Trudeau for fifty-one minutes and described him as "a beautiful person." Trudeau felt likewise and put his arm around Yoko for their photo. I felt in some way responsible for that meeting and was gratified that my heroes were fans of each other.

Soon after the Rock and Roll Revival concert, strange rumors began circulating that Paul had been dead for years, was replaced by a look-alike, and that the Beatles had been giving clues about it since the release of "Strawberry Fields," with John supposedly singing faintly at the very end "I buried Paul." The *Abbey Road* cover was rife with these clues. John was the preacher, George the undertaker,

Ringo the mortician, and Paul the cadaver, dressed and barefoot. The rumor took on a media and fan frenzy. Everyone was searching for clues. I played "Number nine, number nine" from the beginning of "Revolution 9" backwards and definitely heard "Turn me on dead man, turn me on dead man." The *Sgt. Pepper* cover was replete with symbolism. Sgt. Pepper's Lonely Hearts Club Band was watching the burial of Paul, along with the old Beatles, and many personalities. I devoured every bit of information, listened to every Beatles record backwards, studied every album cover to either verify what others were saying or find my own clues. To make matters more beguiling, the Beatles were not commenting on it, and Paul was nowhere to be found until *Life* magazine located him and Linda on his Scottish farm. In their November 7, 1969 issue, the cover was a picture of the couple with their two children under the headline "Paul is still with us." That did not satisfy everyone, but it underscored what really was happening. Unknown even then to the world, the Beatles had broken up and had all gone their separate ways. We would not find out about it for months, but in the meantime, word spread that another Beatle album and a film were imminent. I was elated. Ed Sullivan announced on his February 8, 1970, show that the Beatles would premier two songs on his show the following week, almost six years to the day of that first historic broadcast. I don't think I slept at all that week.

The Beatles had sent two videos. They were from what would become the *Let It Be* album, and had been recorded before *Abbey Road* but not released. The plan had been to document on film the Beatles rehearsing new material for an album and then performing it and recording it live in some exotic location. It was to herald their

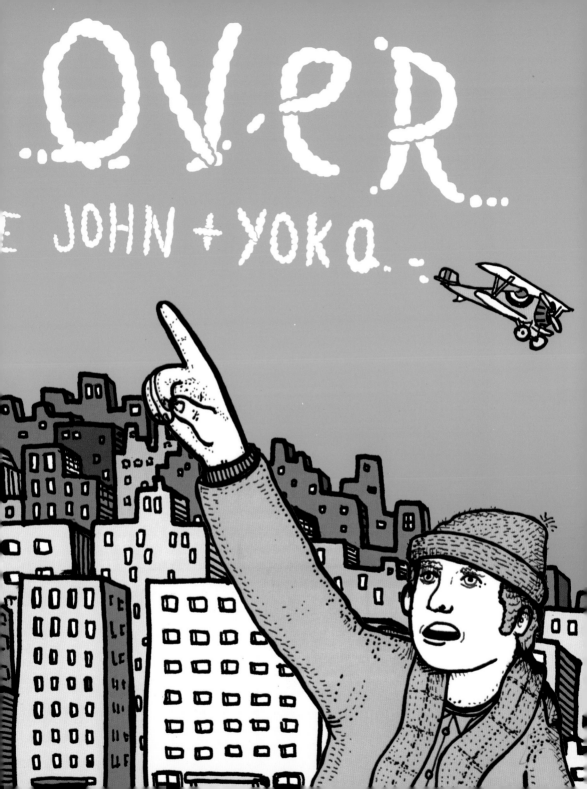

return to a live concert. Sullivan screened the Beatles performing two songs, "Two of Us" and "Let It Be." The Beatles had clearly gone through dramatic changes. They looked fatigued and weary. Adorable Paul was in full beard at the piano, a striking contrast from the "Hey Jude" video. John seemed withdrawn, George detached, and Ringo depressed. And yet the songs were beautiful and classic, particularly the spiritual "Let It Be." I remember loving the songs but being a bit worried that maybe the rumors were true.

On April 5, 1970, the Plastic Ono Band was back with the Phil Spector produced, uplifting "Instant Karma (We All Shine On)." John was consistently releasing songs, creating media events, and staking out an independent position with Yoko on the pop scene. He was not in hiding like Paul. I loved the fact that there were new Beatle recordings, and I was entranced by what John and Yoko were doing and let everyone know about it. I had a lot of defending to do because most people didn't get it and were accusing Yoko of breaking up the Beatles.

Within weeks of the release of "Let It Be" the single, Paul McCartney announced on April 8, 1970, that he had quit the Beatles. Even though John was the one to bring it to an end after the Rock and Roll Revival, Paul decided to arbitrarily proclaim it in a mock-interview press release that was contained in his first solo album, *McCartney*, that hit the shelves nine days later. In response to a question as to whether he could foresee Lennon/McCartney being a songwriting partnership again, his answer was a curt "no." I could not go to school for days. I did not answer the phone. I locked myself in my room and tried to contemplate a world without the Beatles.

Only when I began to realize that they would individually still make music did I come out of my cocoon and go back to school—albeit dressed all in black.

On May 8, 1970, *Let It Be*, the album, was released. It was to be their final album together. The cover consisted of four single photos of each Beatle alone, not together as a group. The songs were not supposed to be heavily produced. In part they weren't—it was the four of them playing, sometimes with Billy Preston on piano and organ, as if it were live. Phil Spector was called in after the fact by John and George, to go through the hours of tapes and come up with an album. Paul would go so far as to raise this in the future litigation and claim that it was a deliberate attempt to ruin his songs, particularly "The Long and Winding Road," with a syrupy orchestral and choral overdub. But the power of the music was undeniable. And the message, as I saw it, was a conscious attempt to have fans come to grips with the end. Spiritual, rocking, and lyrical, it set the right tone for me to lick my wounds and realize that my heroes had not gone away, but were ever present and would be with me forever.

Reality completely set in when I went to see the premier of the film *Let It Be* about a week later. There they were, just as in the Sullivan videos, depressed and detached, but now in deep discord. They were at one another's throats. The film documented, unwittingly, their breakup. John clearly in love with Yoko and dependent on her; George alienated and frustrated by the musical restraints on him; Ringo utterly lost; and Paul desperately trying to keep it all together. In one classic scene that sums it all up, George

in response to Paul's directions on how he should play a lead guitar riff, says, "I'll play what you want or I won't play at all. Whatever it is that'll please you, I'll do it." You knew it was over and they had had it.

And yet to end the film, in a typically inspired act of originality, they gave their last concert on the roof of Apple, to stunned onlookers and the dismay of the London financial district. Hoping to get arrested by the deferential London bobbies, they played like they did in the Cavern, as a group, tight and aiming to please. "Don't Let Me Down," "I've Got a Feeling," the trippy "Dig a Pony," one of the first Lennon/McCartney compositions "One After 909," and "Get Back." It was John who summed it up: "Thank you . . . and I hope we passed the audition." It was as classic a line as when he said to royalty at the London Paladium in 1963: "Will the people in the cheaper seats clap their hands? And the rest of you, if you'll just rattle your jewelry." John Lennon was the working class hero from the meteoric start to the disintegrating end.

Surprisingly, it did not take me long to adjust to the breakup. All of the Beatles produced volumes of solo material to keep me busy. Ringo released his *Sentimental Journey* album, covers of love songs, a few weeks before *McCartney*. George released his spectacular and massive *All Things Must Pass* in November 1970 and quickly became the best-selling solo Beatle record at the time. In December, John released his *John Lennon* album, the product of primal therapy with Dr. Arthur Janov, along with the historic Jan Wenner interview in *Rolling Stone* magazine, in which he debunked the myths and

the glitter of the Beatles and vented graphically and brutally. My prediction of the Beatles saga, and records, was coming true. Even in their time of discord, we all followed intently the biggest storybook of all, the story of the Beatles. Their ups and downs, their trials and tribulations, were all part of the greatest pop story of all time. And all the while, rumors continued that they would get back together. What no one knew at the time was that the Beatles' story would not end with a reunion but instead take a dramatic and historic turn.

On December 8, 1980, while giving a bottle to my son Daniel at midnight, I turned on the radio. "(Just Like) Starting Over" was playing from John and Yoko's *Double Fantasy* album. Released a couple of weeks before, it was John's triumphant return. He had been reclusive, focusing on his family and like me, his young son, Sean. He had been absent from the music world for more than six years, and this was the first album of original John Lennon songs since *Walls and Bridges*. It was climbing the charts and I was happy to have John back. "Beautiful Boy" on that album was his song for his young son Sean, and I would sing it as a lullaby to mine.

I was happy and content, looking into Daniel's drowsy eyes. "Starting Over" was coming to an end. "John Lennon," the announcer said, "Dead at forty. Shot by an assassin's bullet." Stunned beyond words, I held my sleeping son in my arms and wept.

EPILOGUE

After John Lennon died, life continued with the usual ups and downs. Like always there was good and bad, but the optimism that I felt from the moment I first saw the Beatles on Ed Sullivan was a bit tarnished. Within two years my Dad died. So did my Uncle Mike. In 1994 everything changed. My mother passed away after a long illness. I was suffering under the pressures of a busy law practice and my marriage was collapsing. All of it combined proved to be too much for me. Despairing and defeated, I spent my forty-first birthday in a psychiatric ward.

In retrospect my breakdown was the sort of catalyst I needed to get my life back on track. And as usual it was music—the Beatles and John Lennon—that was my salvation. My daughter Rebecca brought me my guitar, and I would play Beatle songs. I also began writing some of my own.

When I was released from the hospital I began the difficult task of rebuilding my life. My brother told me about a new Beatles project

about to come out that was just the salve I needed. The Beatles had produced a three-volume collection of never-before-released versions of their songs called *Anthology*. It would be accompanied by a three-part ABC television special. And two new Beatle songs were on their way: "Free As a Bird" and "Real Love," both written by John and with his voice singing lead.

Four months after being released from the hospital, I watched the first episode on November 19, 1995. There they were, my old friends John, Paul, George, and Ringo, telling their story with rare footage and their personal narratives. It was comforting to see that the surviving Beatles clearly still loved one another, and there was no trace of discord. And the prospect of hearing new Beatles songs did my head and heart a lot of good.

Yoko had given Paul, George, Ringo, and George Martin a few unfinished songs John was working on before he died. They would produce "Real Love" and "Free As a Bird" as if "John was on vacation," as Paul said. During the telecast, ABC tagged now and then onto the screen the time left to hear the "brand-new Beatle song," just like CHUM's "world premier." At the end of that first broadcast, they played the "Free As a Bird" video, a montage of all those familiar Beatle images with the song. Starting from Ringo's familiar solitary drumbeat to the ending clip of John Lennon's voice, it did not disappoint me. To hear Paul and George lovingly add a chorus and complete their mate's song was nothing short of miraculous.

One day, a few weeks before the *Anthology* broadcast, my phone rang. It was Pierre Trudeau. We had become friends during

my brief foray into politics. I had been courted years before by the Liberal Party to run for Parliament. At that time I made it clear that I wanted to meet him before I made any decisions. It was arranged and when we first met in Montreal I told him, "Mr. Trudeau, I had two great heroes growing up. The Beatles and Pierre Trudeau." He blushed and replied, "I can understand the Beatles, but I'm just an ex-politician." That day we talked more about John Lennon and the Beatles than about politics. I told him how I felt responsible for his meeting with John and Yoko, and I told him I would send him a copy of the tape, which I did. He was a great lover of the arts, particularly poetry. His knowledge was vast and he could quote verse at the drop of a hat. He told me that what appealed to him most about John was that he was "a great poet." I asked him what he thought of Yoko. He told me that he had been in touch with her since John's passing and had visited her in New York. "She is one of the most remarkable women I have ever met."

The day he called, he suggested I come to see him and to bring my kids. He had heard that I had been unwell. "Thank you so much, Mr. Trudeau," I told him. "We're friends, Jerry," he had answered. "It's about time you called me Pierre."

Trudeau died in 2000 and I realized then that my heroes had mostly all passed away. I was fatigued with the life I led. Not being able to hear a new song from John or have a chat with Trudeau made the world a dimmer place. Increasingly, I turned to the creative things that inspired me as a child. Most importantly, I decided to do something artistic, as a tribute, with my story. For years I had been approached to sell or exploit my John Lennon material. I had never

been happy with the ideas. Finally, I decided it was time. I started to talk to local artists about doing a short film using my original material. I was not a filmmaker but I threw myself into the process. It was the same determined approach that led me to John and Yoko's hotel room. I had decades before thought of a title for anything I would do about my experience: *I Met The Walrus*. It always had such meaning for me.

I began to work with a young Toronto animator named Josh Raskin on the film. He introduced me to the work of a young Montreal illustrator, James Braithwaite, whose work I loved. His drawings had the wit and aesthetic of John Lennon. The three of us met and began planning the immediate production of *I Met The Walrus*. Best of all, these young fellows loved the Beatles, were captivated by my story, and brought great enthusiasm to this crazy idea.

A makeshift studio was set up over a paint store in downtown Toronto. Once a week or so I'd check in with them. From the first of James' drawings I was amazed at my great luck. They were compelling, made with respect for John, his words and my experience. Within a year, the film was finished and I got the nervous call from Josh. "Jerry, it's done," he reported to me. "We want you to see it." I rushed over to the studio and sat down with my young and nervous friends. I was astonished. It was beautiful, provocative, funny, and a fitting tribute to my hero. "If this is all that happens to the film, guys," I told them teary-eyed, "I am a happy man."

It did not take long for the accolades to come in. We submitted *Walrus* to film festivals. I made it clear from the outset that I would not commercialize or exploit it, and we were careful where it went and how it was presented. Soon after it was completed, I sent it to

Yoko Ono and told her it was a loving tribute to John. I hoped that she would look at it, that she would like it, and that I would hear from her. We began to win top awards around the world. The Middle East International Film Festival, an Arabic festival in Abu Dhabi, honored a film produced and directed by Jews and about John Lennon, whose music was banned in many Middle Eastern countries, talking about peace. In the summer of 2007 we received word that the American Film Institute Festival had chosen our film as Best Animated Short. The significance of this did not escape us. We were in the running for an Academy Award nomination.

And then the news came. We were short-listed for an Oscar nomination. Out of thousands of short animated films from around the world, we were one of ten chosen. That meant we had a 50 percent chance of being nominated. My life, which had been so complex and unusual, had now entered the realm of surreal. The Oscar nominations were announced in the early morning of January 22, 2008. I was driving my daughter Jaime to her first-grade class on a snowy, frigid day. My car got stuck on a hill beside the school, as other parents were skidding and cursing trying to get their children to class on time. My cell phone rang. It was my girlfriend Anisa. She softly said to me, "Oh my God, Jerry, you're nominated. You're nominated for an Academy Award." "I can't believe this," I said, and told her I would call her back. Jaime asked me what was wrong. I pulled the emergency brake and stopped the car. I turned around and said to my six-year-old, "A wonderful thing has happened to your Dad today and a wonderful thing for our family."

After I dropped Jaime off and got back in the car, my cell phone rang again. It was a member of the Academy, Ron Diamond, who was a great supporter of the film. I had heard of him but had never talked to him. He called to congratulate me and told me about the screening he attended that led to the nomination amongst members of the animation section of the Academy. He told me there were tears in the eyes of the people in that room when they heard John's voice, talking about peace to a fourteen-year-old. Choking up, he said, "I can't tell you what it meant to hear our old friend John talking to us again, especially now, and talking about peace." I thanked him profusely and hung up the phone. The adventure I embarked on that Sunday night so long ago had come to this. I thanked God, whom I thought had abandoned me so many times before, and I sent a prayer to John Lennon.

At the 2008 Academy Awards, Anisa and I walked the red carpet a bit disoriented. Penelope Cruz was in front of us, Cate Blanchett behind. When I walked to our seats, I passed George Clooney, Harrison Ford, Daniel Day-Lewis, John Travolta, and even Mickey Rooney. Everyone said hello as though we were part of a club. I guess we were. Our seats were seven rows behind Jack Nicholson. And then the extravaganza began. As the show progressed, it was bizarre to say the least as I heard Jerry Seinfeld's voice announce *I Met The Walrus* as the first nominee in the short animated film category. In fact the image they flashed on the screen was James' drawing of me as a fourteen-year-old with a reel-to-reel tape recorder. Many moments of my life were truly exceptional but I could not begin to describe the stunning, humbling feeling as I

waited to hear the winner. I had gotten to know the director and producer of *Peter and the Wolf* and personally thought it to be the best film in our category. I smiled when they were chosen, tapped Josh on the knee to comfort him, and rose to embrace the winners. I sat down and for the first time, started to enjoy, really enjoy, my experience.

Shortly before the end of the show, I whispered to Anisa that I had a great line for Jack Nicholson. She gasped, and I said, "Trust me." As soon as the show ended, I took her by the hand and led her down the carpet to the front row. I walked up to Mr. Hollywood, sunglasses and all,

took his hand, shook it, and nose to nose said, "Hi, Jack. I'm an Oscar loser." He smiled and raised his sunglasses. "You know," he said, "I was telling my friend Tommy Lee Jones, have you ever been to one of these and lost? And have you noticed how your friends can't look at you? So let's take a look at you?" Peering me up and down, he wasn't finished. "And who is this?" he asked, checking Anisa out. "It's my girlfriend, Anisa," I proudly answered. "Well, you don't look like a loser to me," he said and firmly planted a big Hollywood kiss on her astonished lips.

My life is as complex today as it ever was. It is filled with love and challenge, hopes and fears. I met my heroes—all of them. I got to know two of them. One of them gave me a gift that has taken me through the mountaintops and valleys of my life. He was one of the most important figures of the twentieth century. He was John Lennon. He was the Walrus. He has been with me in my pools of sorrow and my waves of joy. My memories of him drift through my open mind, possessing and caressing me.

For John

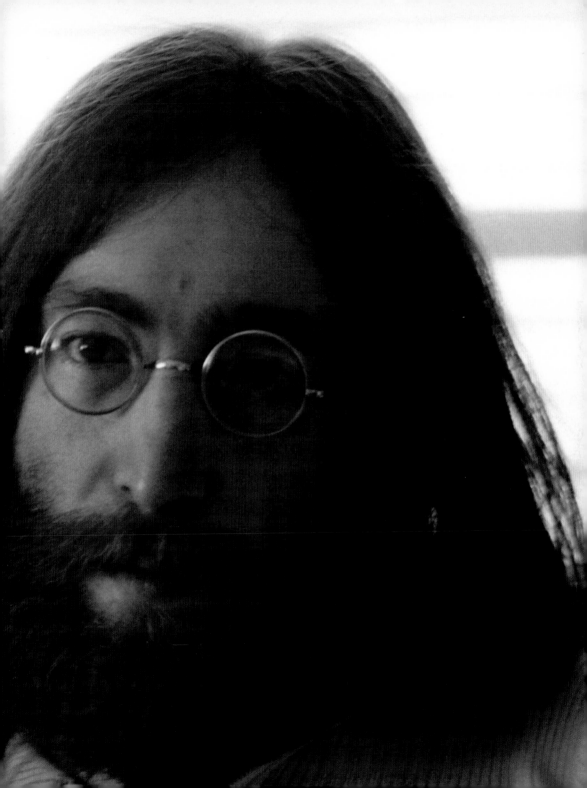

ACKNOWLEDGMENTS

Within a day of attending the Academy Awards, I received a wonderfully succinct e-mail from Julia Abramoff at Collins Design expressing interest in my story, and she has been responsible for keeping that crazy train rolling all along. She was a prelude to my introduction to the magnificent Marta Schooler, vice president and publisher at Collins Design. Every communication, thought, and direction from Marta was filled with integrity, intelligence, determination, and the joy of giving stories life in books. I am so grateful that she was taken by my tale and that she unwaveringly guided this book through to fruition. She understood everything and introduced me to the incredible team at Collins Design, including associate editor Dinah Fried, art director Ilana Anger, and designer Agnieszka Stachowicz, all of whom made the pieces come together in a beautiful way.

I am so happy Marta found Aaron Kenedi to be the editor for this project; his instinctive and insightful attention to all things related to *Walrus* made me confident that I was in good hands.

Not that I am a stranger to big cities, but New York is as big a city as it gets and my agent Victoria Skurnick was my protector, advisor, supporter, confidant, and humorist. She allayed every fear, every insecurity, with honesty, directness, and compassion.

Susanne Boyce, president of Creative, Content and Channels of CTVglobemedia Inc., championed my film with remarkable devotion and genuineness and led the amazing CTV team that touched so many Canadians with my narrative. I would like to thank J. D. Cargill, CNN's entertainment producer, who embraced my story all the way to the

limo ride he arranged for the Oscars and the simulcast at red carpet time with enthusiasm and great professionalism.

Sara Angel was responsible for instilling in me a sensibility for the craft of writing and the publishing world. She told me in a moment of self-doubt that I should find my voice and just write it. When I showed her the first draft, she said, "You found it!" My friend Jeff Sackman kept me sane during the Oscar deluge and its aftermath with his great knowledge of the film business and precise rationality. He has been a loyal and true friend. Carmen Dunjko took me under her creative wing at a time of difficulty for me and encouraged and applauded my artistic forays with the certitude of mind that is her hallmark. Her husband and partner, Barnaby Marshall, kept me on track with his passion for rock and roll and the great insight he has for the facts and mythologies that surround it. A very special mention goes to the spectacular sculptor Sorel Etrog who saw a kindred spirit in me, opened my eyes and rejoiced in my artistic endeavors.

Much thanks to Byron Wong, who kindly took my reel-to-reel audio—something so precious to me—and spent so much time and care in bringing it to life, and Doug Laxald and his team at Gas Company who meticulously and tenderly restored my photos and images to their present glory. Justin Broadbent, who worked on the film and other projects with me, lent his magnificent talent and whimsy to the design of the DVD insert—it was a happy bonus to have him be part of this project. The brilliant Ruben Huizenga, my friend and musical collaborator, spent countless hours showing me the DNA

behind Beatle music. We talked at length over the last few years about the impact of my story and the music I loved. He understood every idea and emotion.

CHUM Radio is a big part of my story, and I had great help from CHUM producer Doug Thompson (who was at CHUM when I met John) and program director Brad Jones. I also want to thank my friend Peter Miniaci, one of the world's great Beatle experts, for years of sharing Beatle stories.

Yoko Ono is well served by her lawyers Peter Shukat and Jonas Herbsman. Their civility, directness, and accessibility throughout the Academy Awards process and this book have been nothing short of remarkable. I should know. I am a lawyer.

What a twist of fate that I found Josh Raskin, who had such great ideas and such a zest for creating the film that he animated and directed. He spearheaded the finished result that is acclaimed around the world. He also introduced me to the gloriously talented James Braithwaite, who brought life to our film with his striking illustrations. The first drawing I saw of his sold me on making the film. That we collaborated yet again on this book gives me great satisfaction.

My brother, Steve, was there when it all happened. He was there when I first listened to Beatle records and when I walked on the clouds on May 26, 1969. He has been my supportive rock during the Oscars and this book. He guided me with insight and affection and I have been so taken by his dedication and attachment to my story. My sister, Myrna Riback, was responsible for me listening to the Beatles, it was her record player and her records, and she took Steve and me to *Help!* and *A Hard Day's Night*. She helped me piece together the history of our family and I am so thankful.

Cora Dela Cruz and her wonderful family have always been there for me with loving friendship and support. Cora helped my ill mother place the call to a live phone-in TV talk show I was on to jokingly ask, "Why didn't you tell your mother you weren't going to school?"

Greig Dymond, my true friend and fellow Beatle aficionado, gave me constant advice and support with his unparalleled knowledge of pop culture and all things related to the Fab Four. He too saw me through Oscar's wild ride and gave me repeated, constructive guidance in the writing of *Walrus*. Most importantly, he was with me at my darkest times, with my great friends David Lepofsky, who laughed when I told him I feared a life of mediocrity, Karen Cohl, and Mel Crystal. It was there, with their support, that I hatched the idea of telling my story.

My son, Daniel, has spent twenty-eight years hearing me and others talk about the Beatles and my meeting with John Lennon when I was fourteen. Through it all we shared our love of music and exposed each other to new sounds and recordings. It was he who walked me out of the hospital and into my new life. My sweet daughter Rebecca embraced my love for the Beatles probably before she was born and even forgave me for setting up a birthday lunch with a Ringo imposter. To this day she joyously tells me what songs she has rediscovered and is as proud as a child could be of her father. I am so thankful to my daughter Joanna, who understood my worship of John, for keeping me on my toes for so many years by asking me existential questions like, "Dad, if you could be a member of the Beatles but John still had to be dead, what would you choose?"

Needless to say, I always chose not to be a member of the Beatles. It was my seven-year-old, Jaime, who was with me when I heard the news of the Academy Award nomination. Her understanding of the gravity and glory of the news was immediate and visceral. Through her eyes I see the wonder of it all and the wonder of things to come.

My love Anisa Tejpar has seen me through such wildly wonderful and turbulent events, all in the last few years, which would have been so lonely and unbearable without her by my side. Bold, beautiful, and loving, what caring and engaged witnesses we have been to each other's lives.

Yoko Ono is inseparable from the Beatles story. She was John's loving wife, collaborator, and partner, and infused dramatically intelligent and courageous creativity into his pursuits. The peace campaign was as much her inspiration as it was his. She in so many ways and in so many things, as John said to me, was a visionary. The generosity of her spirit in my film and in this book has been a blessing to me.

The focus of my story is on one Beatle, but oh Lord, how I loved them all. Paul McCartney is fundamental to what has driven me all these years. Had he been at the King Edward, I most certainly would have wanted to find him. John without Paul and Paul without John would not have made the Beatles. I simply cannot imagine this world without what those four special souls gave us.

And John. After all these years, with all your accomplishments and the magnitude of your impact, look at how you affected just one fellow from Toronto. You surpassed my wildest expectations. I met my hero and he was better than I imagined. Thank you, eternally.

PHOTO CAPTIONS

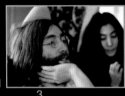

1

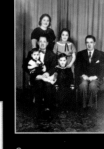

2

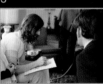

4

5

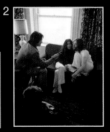

6

7

8

9

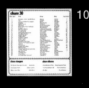

10

1. Copyright page: A rare photo of John and Yoko taken by a *Toronto Star* photographer the day I met them. Jeff Goode/*Toronto Star*.

2. Title page: John and Yoko being interviewed. I had just snuck into their room. That's the back of my head in the foreground. Jeff Goode/*Toronto Star*.

3. Table of contents: John signs his name and draws a caricature of him and Yoko on the *Two Virgins* album for me. Jeff Goode/*Toronto Star*.

4. Page 8: My favorite photo. John and Yoko sweetly holding each other's hands and looking at each other's fingers. I was struck by how beautiful Yoko was.

5. Page 21, top: My mother Judith and my father Chonon.

6. Page 21, bottom left: The Levitan clan with my uncle Mike.

7. Page 21, bottom right: Me at 14. Photo by Haim Riback

8. Page 43: The back cover of a rare copy of the *Two Virgins* album. I was one of the first in North America to buy this album before it was confiscated by the police at customs. It surprised John that I had it.

9. Page 47: A copy of the invitation to the Jerry Lewis telethon, which led to my first trip to New York.

10. Pages 54–55: The CHUM Chart, a weekly listing of the most popular songs of the day. Doug Thompson/CHUM archives.

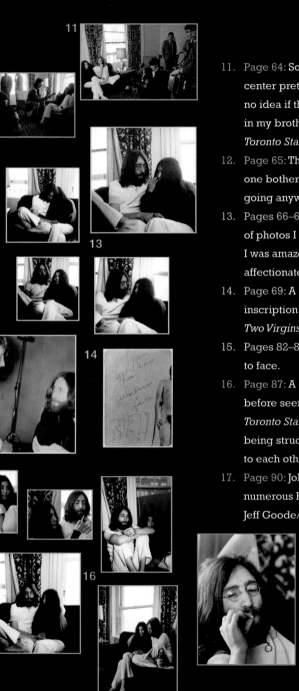

11. Page 64: Somehow I am front and center pretending to be a reporter. I had no idea if there was even film in my brother's camera. Jeff Goode/ *Toronto Star*.

12. Page 65: The best seat in the house. No one bothered to move me, so I wasn't going anywhere. Jeff Goode/*Toronto Star*

13. Pages 66–67: John and Yoko in a series of photos I took with my sister's camera. I was amazed and impressed by how affectionate they were with each other.

14. Page 69: A close-up of John and Yoko's inscription on my copy of the *Two Virgins* album.

15. Pages 82–83: Me and my hero, face to face.

16. Page 87: A collage of rare and never before seen photos taken by me and the *Toronto Star* photographer. I remember being struck by how attentive they were to each other. Jeff Goode/*Toronto Star*.

17. Page 90: John smoking one of his numerous French Gitanes cigarettes. Jeff Goode/*Toronto Star*.

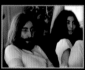

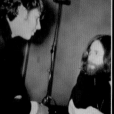

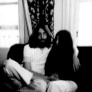

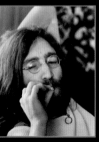

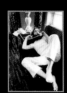

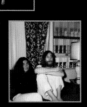

18

20

19

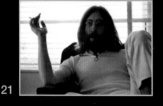

21

22

23

24

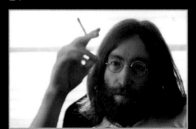

18. Page 94: More photos by me and the *Toronto Star* photographer Jeff Goode. Jeff Goode/*Toronto Star*.

19. Page 101: The front and back cover of the *Life With the Lions* album. The front photo shows John sleeping by Yoko's side on the hospital floor after her miscarriage in 1968. The back is a photo from John's earlier marijuana bust.

20. Page 107: The "secret code" John gave me to be able to contact him.

21. Page 108: John opens up about peace, love, war, music, and the fate of the Beatles. Jeff Goode/*Toronto Star*.

22. Page 113: After spending a day with John, he treated me to a night on the town with popular recording star Mary Hopkin.

23. Pages 124–125: Mary Hopkin surrounded by admirers after her concert.

24. Pages 156–157: A final shot of my hero, The Walrus, John Lennon. Jeff Goode/*Toronto Star*.

I MET THE WALRUS

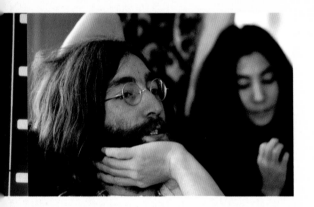

For information, please write:
Special Markets Department,
HarperCollins Publishers,
10 East 53rd Street, New York, NY 10022.
First published in 2009 by
Collins Design
An Imprint of HarperCollins Publishers
10 East 53rd Street
New York, NY 10022
Tel: (212) 207-7000
Fax: (212) 207-7654
collinsdesign@harpercollins.com

Distributed throughout the world by
HarperCollins Publishers
10 East 53rd Street
New York, NY 10022
Fax: (212) 207-7654

Book Design by Agnieszka Stachowicz
Illustrations by James Braithwaite

ISBN: 978-0-06-171326-2
Library of Congress Control Number: 2008941117
Printed in China
First Printing, 2009